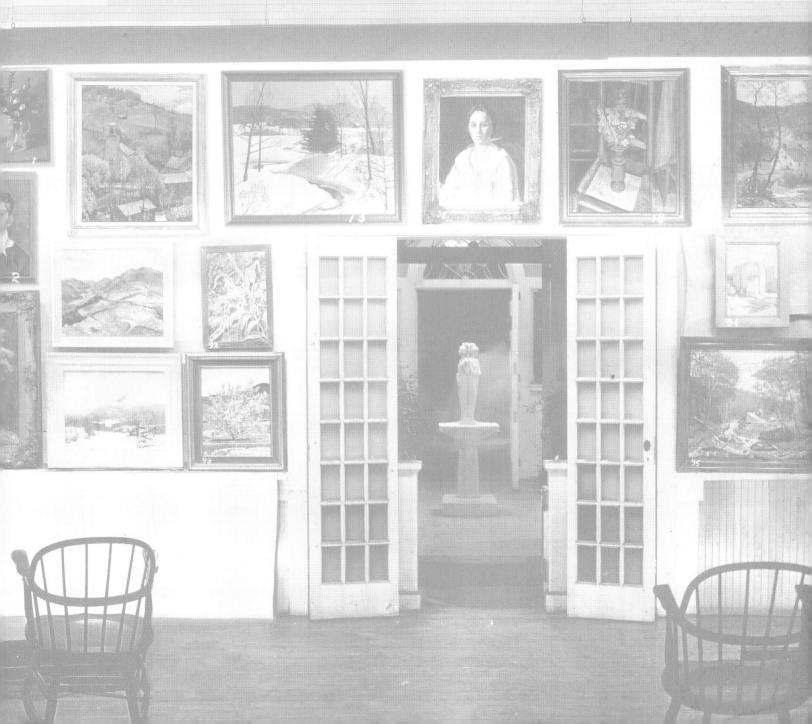

Art and Soul

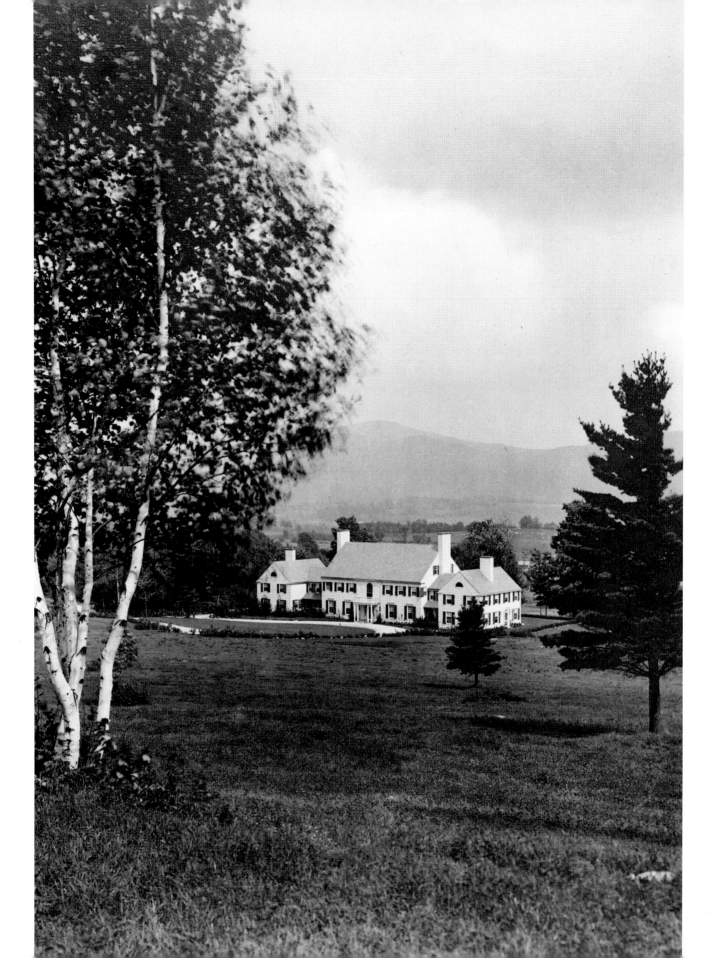

Art and Soul

The History of the Southern Vermont Arts Center

by Mary Hard Bort

Margot Page, *Editor*

SOUTHERN VERMONT ARTS CENTER

MANCHESTER, VERMONT

2000

A NOTE TO THE TEXT In May 2000, the Board of Trustees and the members of the SVAC voted to adopt "Southern Vermont Arts Center" as its legal name, replacing "Southern Vermont Artists, Inc." and changing "Art Center" to "Arts Center." The author's manuscript was written 1995–99, prior to the change.

Library of Congress Cataloging-in-Publication Data

Bort, Mary Hard.
 Art and soul : the history of the Southern Vermont Artists and the Southern Vermont
Arts Center / by Mary Hard Bort; Margot Page, editor.
 p. cm.
 Includes index.
 ISBN 0–9669382–4–0 (paper)
 1. Southern Vermont Artists—History. 2. Southern Vermont Arts Center—History.
 3. Arts, Modern—20th century—Vermont. I. Page, Margot. II. Title.
 NX805.V47 B67 2000
 760'.0743—dc21 00–034768

Designed and produced by Randall Perkins & Leslie van Breen
Gallery Press LLC, Manchester, Vermont 05254
Printed in Singapore by CS Graphics, Inc.

First Edition 10 9 8 7 6 5 4 3 2

COVER Painter Elsa Bley at her easel in Dorset. FRONTISPIECE Yester House, c.1960

CONTENTS

PREFACE

GREAT ART IS NOT CREATED IN A VACUUM. It is born of a time and culture. The visual and performing arts together illuminate the society that nurtures them and allow us profound insight into a time and a place, and into the individual creative mind.

These are lessons I learned in college and graduate school, but in actuality I had known them for years. Like many residents of Manchester, Vermont, I grew up roaming the galleries of Yester House and attending performances in the Arkell Pavilion. This wonderful center for the arts has played a pivotal role in my life, as I am sure it has for many of you. Like other visitors to the Southern Vermont Arts Center, I have always wanted to know more about how this special place came to be. Now we have *Art and Soul: The History of the Southern Vermont Arts Center.*

My pride in being asked to write a preface to this book knows no bounds. All of you who love this special place "on the hill" share my excitement that Mary Bort has written a wonderful record of our Arts Center. To read the fascinating story of the early founders is to strengthen our resolve to renew their goal—"to further art in all its aspects, to serve the arts and the community"—and to fulfill their vision.

No one served the arts with more vision and commitment than my mentor and the Arts Center's dear friend and benefactor, the late Betty Wilson. A true philanthropist, she was passionate about the arts and wanted others to feel her excitement. Her generous bequest catapulted the Southern Vermont Arts Center into the twenty-

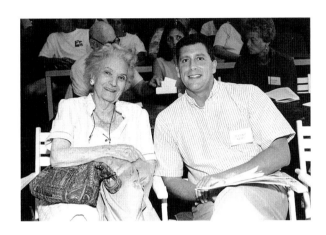

Betty Wilson and Christopher Madkour preparing to bid at the first Fine Arts Auction, August 1997

first century. Without the work of Betty and, indeed, her mother, Louise Arkell, the history Mary Bort would have written would be far different.

Mary has given us a marvelous overview of the history of the SVAC. It is, of course, impossible to include the names of everyone who has contributed over these eight decades to the growth and health of the Arts Center. Please forgive omissions; they are simply the result of space limitations. We are indeed grateful to every one of you.

I would like to give special recognition, however, to Bird McCormick and Roby Harrington for their generosity in underwriting in part the publication of *Art and Soul: The History of the Southern Vermont Arts Center*. In addition, I would like to acknowledge the SVAC's dedicated and loyal staff who have contributed greatly to its success. Because of their vision the Arts Center begins the new century by celebrating its history and pointing the way to the challenges that lie ahead.

Christopher J. Madkour
Executive Director

INTRODUCTION

It is the misfortune of us painters that we cannot let beauty alone. We are not content to see and enjoy it. Something uncontrollable makes us go out and try to do something about it.

EDWIN B. CHILD, 1935

WHY SO MANY ARTISTS chose to "try to do something about it" in the Vermont villages of Dorset and Manchester, we can never really know. Suffice it to say that they did and continue to do so, to our great benefit. Just as The Southern Vermont Art Center really began with the artists themselves, so too does this history.

The Southern Vermont Artists, Inc., formed December 11, 1933, is a member organization, led by an elected board of trustees which administers the Southern Vermont Art Center, hires a director, is responsible for its fiscal affairs, and determines its philosophy. This unique organization, which melds the gifts of artist and non-artist alike, has evolved into a rare and vital partnership that transcends probability—sometimes even possibility.

Up until 1933 membership was a casual matter. Artists joined the organization to ally themselves with other regional artists; non-artists joined to lend their financial and moral support to the arts and the artists. After incorporation in 1933, and until

after 1943, members were elected, having first made application and expressed a willingness to follow a dues structure. Since 1945, members are welcome to join by simply paying dues, with Artist designated a special category of membership, along with Individual, Family, Donor, Patron, Benefactor, and Fellow.

The story of the evolution from a simple association of a few regional artists to Vermont's oldest arts organization with several thousand members scattered throughout the world is an interesting one. Some of the coincidences that accompanied its development defy credibility. The passion that made things work and the dedication that kept people going through some very difficult times are all a part of that story. What can never be told nor documented are the expenditures of time and treasures that have gone into this living, growing, developing entity. It is a story without end.

It is, at its heart, a story of people.

Mary Hard Bort
Manchester, Vermont 1999

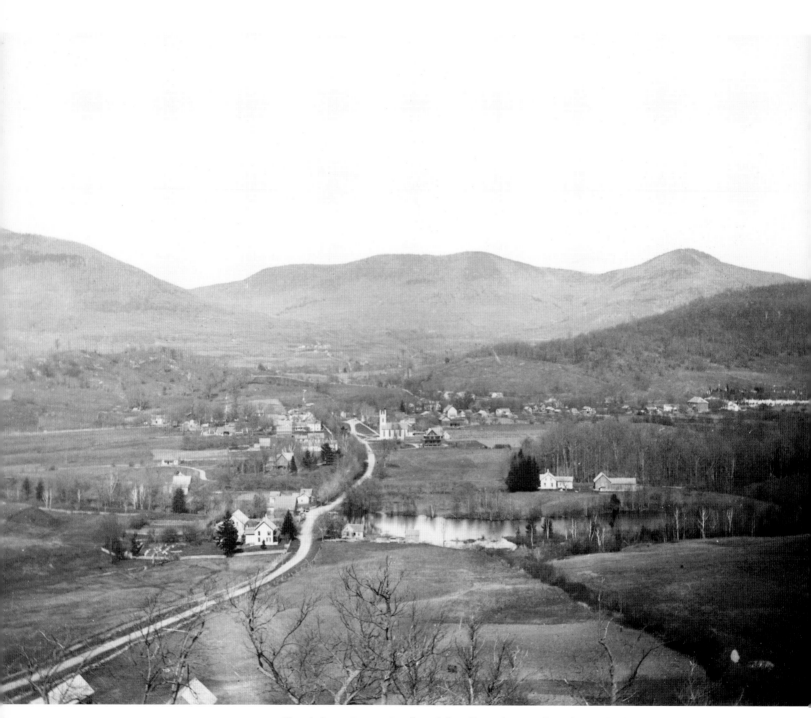

Church Street, Prentiss Pond, and the village of Dorset from the north side of Mother Myrick Mountain, c.1900

The Dorset Painters

O<small>N A SULTRY LATE</small> A<small>UGUST DAY</small> in 1922, at the Town Hall in Dorset, Vermont, history was made. In this quiet hamlet of white clapboard houses where artists had been gathering during the summers for some thirty years, an exhibition of the work of five local artists was held. Those artists, Edwin B. Child, Francis Dixon, Wallace W. Fahnestock, John Lillie, and Herbert Meyer, would come to be known as The Dorset Painters and would form the nucleus and beginning of the renowned Southern Vermont Artists.

But on that August day, local people came to see the work of their neighbors, visitors stopped by to see what was going on, summer people came to assess the quality of the work, and the ladies of the village served punch, tea, and cookies to all. It was a Dorset social event and the start of something much bigger that would eventually encompass the entire Battenkill valley.

One of the Dorset Painters, Edwin B. Child, was the son of the Rev. Jonathan Child and was born in Gouverneur, New York, in 1868. He graduated from Amherst in the class of 1880 and married Anna Sykes of Dorset, Vermont, in 1894. He studied art at the Art Students' League in New York where he also taught as an assistant to the famed John LaFarge. Well-known throughout the country for his portraits, his landscapes of the Dorset area are also much admired.

During his most productive years, Child won numerous awards and received many prestigious commissions for portraits of the famous and near famous. His portraits hang in the Court of International Justice in The Hague, at the International

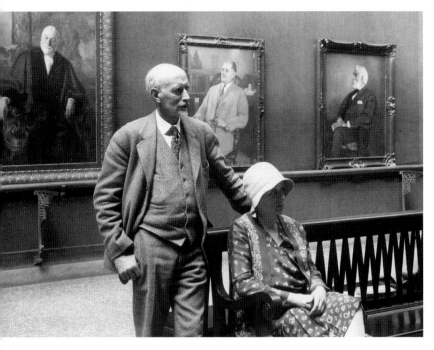

Edwin B. Child and his wife at his one-man show at the National Gallery of Art in Washington, D.C., 1928

Law Library at Columbia University, and at Amherst, among other locations. In 1930 he was invited to exhibit a group of his portraits at the National Gallery of Art in Washington, D.C., for a month—an unusual distinction and the first one-man show ever held there.

On visits to his wife's home, he painted landscapes of the glorious local Vermont scenery and, after spending many summers in Dorset, the Childs moved there permanently in 1927. Child opened his studio to visitors during the summer and was extremely helpful to fellow Dorset Painter John Lillie, doing his best to secure for him the recognition he deserved. Finding a market for art work is seldom easy and Child used his influence generously on Lillie's behalf.

When Edwin B. Child died in 1937 at the age of sixty-nine, he had taken an influential part in the founding of the Southern Vermont Artists and left a legacy of painstakingly accurate landscapes and many fine portraits of well-known people. Over and above these professional credits, he was loved and esteemed by the Dorset and artistic communities.

Another Dorset Painter, Francis Dixon, a resident of Flushing, Long Island, spent several summers in Dorset and the summers of 1924 and 1925 in Manchester. Frequent trips to Europe brought him inspiration from the art galleries there, but his burning desire was to paint the sea. To further that ambition, he spent six years, from 1926 to 1932, cruising the Maine coast studying and painting the ocean. He returned to Dorset one autumn in the 1930s to paint the fall foliage but was never again a summer resident of Vermont. He exhibited primarily at the Babcock Galleries in New York.

Wallace W. Fahnestock (1877–1962) was a protege of John LaFarge at the Art Students' League in New York where he was a fellow student of Herbert Meyer. In 1912, Zephine Humphrey of Dorset commissioned Fahnestock to design a stained glass window for the Dorset church in memory of her mother Harriet Sykes

Far left: MARCH AFTERNOON *by Wallace W. Fahnestock, c.1940, oil on canvas, exhibited at the 27th Annual Exhibition of SVA*

Left: Wallace W. Fahnestock, c.1930

Humphrey. Fahnestock is especially well-known for his paintings of flowers, but he honed his skills by doing landscapes of the local area. He came to enjoy painting landscapes and on trips to Cape Cod found subjects for his brush. He opened his studio to visitors during the summer and this exposure increased his popularity with buyers. Wallace Fahnestock was a founder of the Southern Vermont Artists and his name could always be found on the list of people who were on the hanging committee or the jury of the early exhibitions.

John Lillie was Dorset's much-loved and best-known native artist. Born in 1867, he lived in Dorset all his life and worked as a farmer, mason, carpenter, and builder. Many farm families took in boarders during the summer and the Lillies were no exception. During one particular summer, the house on the West Road was full of landscape painters who often asked John for advice on where to find the best views. The barn was full of drying canvases and John became interested in watching the artists at work.

Oil portrait of John Lillie painted by Claude Dern, 1939

The story goes that one day when all the artists were away from the farm, John found a smooth board and with a shaving brush and some house paint created his first work of art. He placed it among the other drying paintings and when it was discovered the next day, the visitors were lavish in their praise and enthusiasm. The pro-

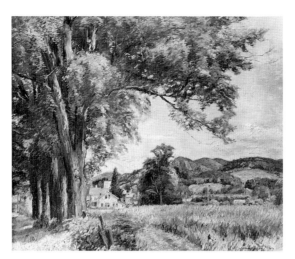

COUNTRY ROAD *by Herbert Meyer, c.1940, oil, 20 x 24 inches, Permanent Collection, SVAC*

Herbert Meyer

fessional men encouraged John but gave him little advice and in the fall took some of his canvases with them to New York—he was their "miracle."

That winter, at the invitation of one of the artists, John Lillie made his first trip to New York City where he was taken to art exhibitions and to the Metropolitan Museum of Art. According to Zephine Humphrey, he was unerring in his judgment as to what was best and unswayed by the opinion of others. When the artist-boarders did not return to Dorset, local excitement over John's pictures abated, and most of the neighbors considered his painting a childish pastime for a skilled craftsman with a family to support.

Around the turn of the century, summer homes were being built in Dorset as well as in Manchester and the services of skilled craftsmen like John Lillie were in great demand, "but he never forgot the joy of the creative impulse." He didn't talk about it but his canvases collected in the hen house and his work was exhibited at Lorenzo Hatch's studio in 1905 for the benefit of the Dorset Library.

In the fall of 1921, a landscape painter came to Dorset, saw John's paintings, and "exhorted the valley folk to appreciate his talent." Visitors came to the hen house to see the simple, stark, austere landscapes—unreal and mysterious. The painter-visitor returned to New York and encouraged a dealer to send for some of Lillie's work. He kept five to show and three of those were sold. So by the time of the 1922 benefit exhibition at the Dorset Town Hall, John Lillie was bound to be included on any list of Dorset artists.

An enthusiastic founder of the Southern Vermont Artists, John worked unflaggingly to ensure the success of that venture. His studio became a meeting place for summer people and artists and, in 1938, some of his work was selected by Homer St. Gaudens to tour the United States. He lived to see his paintings in the Permanent Collection of the Metropolitan Museum of Art in New York, at the Corcoran Gallery

in Washington, D.C., and at the Carnegie Institute in Pittsburgh, Pennsylvania. Some of his work, including a self-portrait, is owned by the Dorset Historical Society. John Lillie died in Dorset in 1942 at the age of seventy-five.

Probably the best known of the Dorset Painters was Herbert Meyer. A member of the National Academy, he painted Vermont in all seasons. He often exhibited at the MacBeth Galleries in New York and works of his were purchased by the Metropolitan Museum of Art as well as by the Whitney Museum and the Addison Gallery of American Art in Andover, Massachusetts. An art critic for the *New York Herald Tribune* characterized Meyer's landscapes as having "gusto and the soul of locality." *New York Times* art critic Edward Alden called him "an artist of great power, sensitive and full of charm." Ann Meyer was the wife of Herbert Meyer and a graduate of the Pratt Institute. Her paintings of nature subjects were popular at the annual shows for many years. Herbert died in 1960.

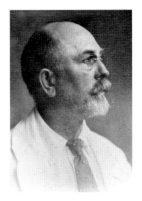

Lorenzo Hatch

Though not one of the Dorset Painters, Lorenzo Hatch (1856–1914) is credited with forming a small summer art colony in Dorset at the turn of the century. His work was often compared with that of John Singer Sargent and James McNeil Whistler. Hatch had come to Dorset as a boy with his mother Frances. His sculptor father had died and his mother returned to her Dorset home. Apprenticed to a watchmaker at fourteen, his copperplate engraving of George Washington came to the attention of the chief of the Bureau of Engraving and Printing in Washington, D.C., and he became the youngest apprentice of that federal agency where his career blossomed. He studied art and exhibited in New York and visited his mother and younger brother in Dorset where he had a small studio behind his mother's house. Engaged by the Chinese government in 1908 to teach the art of engraving, he died in China of kidney disease at the age of fifty-eight.

A 1902 engraving by Lorenzo Hatch commissioned for Bonds of the Japanese Navy, Permanent Collection, SVAC

Lorenzo Hatch's portrait of his mother was donated to the permanent collection of the Southern Vermont Art Center in 1967. A 1906 portrait of his wife, Grace Harrison Hatch, and a spring scene of Mt. Aeolus are the property of the Bennington Museum. A retrospective exhibit of Hatch's work was mounted at the Art Center in 1989.

Cecil Grant displays his paintings at the monument in front of the Equinox Hotel, c.1940

The Manchester Idea

WHEN FRANK V. VANDERHOOF and Francis Dixon arranged for an exhibition of paintings of some artists of Dorset and Manchester at the Equinox Pavilion in 1924, they hoped it would be only the first of a long series of annual exhibits. Dixon was one of the Dorset Painters and Vanderhoof, less well-known as an artist, was a Manchester summer resident.

This first exhibition was held the last week in August when the summer season was at its peak, and ten artists showed their work. Seventy paintings, mostly scenes of Manchester and Dorset, were enjoyed by the hundreds of people who came to the admission-free exhibit.

Exhibitors in this first Manchester show included Edwin Child, John Lillie, Wallace Fahnestock, and Herbert Meyer as well as Manchester artists Laura Hollister, Mary (Mrs. W. F.) Powers, Henry Schnakenberg, Dixon, Vanderhoof, and William Hurd Lawrence of Castleton. Laura Hollister was a Manchester summer resident whose roots in Manchester dated back to its early settlement. She was a good and enthusiastic "hobby painter" who exhibited at SVA shows for many years.

Mary Powers was a strong leader in the early days of the Southern Vermont Artists. In 1927 she took overall charge of the annual show—a role she filled for some ten years. She herself had considerable ability as an artist. Her husband, William, was the head of W. F. Powers Lithographers and he was the organizer of the Lithographer's National Association. The Powers had purchased "Glebelands" from B. F. Carver in 1923 and made it their summer home until William Powers' death in 1927. When Mary sold the property to Anton Hardy she built Bourn Brook Cottage in the

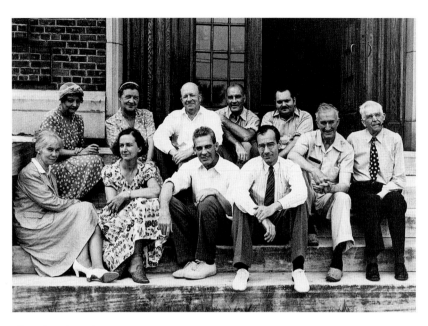

_Some of the founders of
the Southern Vermont Artists,
on the steps of the old Gymnasium of
Burr and Burton Seminary [now
Academy] in Manchester.
Front row: Hilda Belcher, Bernadine
Custer, Wallace W. Fahnestock,
Norman Wright, Horace Brown,
John F. Lillie. Back row: Harriet G.
Miller, Mary S. Powers, Herbert
Meyer, Henry Schnakenberg,
Clay Bartlett_

Downer's Glen area of Manchester and sited her studio there. Later, this was the home of painter Ogden Pleissner.

Henry Schnakenberg was the son of Manchester summer resident Daniel Schnakenberg and a painter of regional landscapes. He was an early member of the Southern Vermont Artists and each year when the time came to choose a jury and hanging committee, he could be counted upon for the long hours and hard work needed to put on the annual show. His work is part of the Permanent Collection in the Fleming Museum at the University of Vermont and at the Southern Vermont Art Center.

August 1927 brought the "Fourth Annual Exhibition of the Artists of Southern Vermont." The show lasted for ten days and among the new exhibitors were Jay Connaway of Peru, E. Lillian Reitzenstein of Peru, Jesse Whitsit of Arlington, and Gertrude H. Grant of Peru, none of whom had exhibited in Manchester before. It was said that more than 1,600 people viewed more than 100 paintings by twenty-four artists. The visitors came from twenty-eight states as well as from Canada, Norway, England, Wales, and Algeria. The August exhibition of the Artists of Southern

Vermont was already becoming the premier event of the late summer season in Manchester.

A review of the exhibition reported that people were at the doors before the show was open and while paintings were still being hung. Some people who had come a long way pleaded with the committee to be admitted. "All day long the crowds came—artists, collectors, gallery attendees, people who have never left Vermont." Many remarks about the high quality of the work on view were heard. *The Rutland Herald* called it "a creditable and illuminating collection including canvasses by artists as well-known as Horace Brown and John Lillie and some even better known in artistic circles."

In 1928 children under sixteen were invited to participate in the exhibition for the first time, so long as their work was "original and unassisted." Each artist submitting work would have one or more pieces included and there was no policy as to the kind of work accepted. Landscapes predominated but a sculpted head of Carl Ruggles by Harriet Miller (now at the Bennington Museum) and a wood carving by Adlai Hardin were included in the work of thirty-nine artists, as was work by Robert Strong Woodward of Shelburne Falls, Massachusetts. As usual, visitors waited at the door each morning before opening. Sales were up, and over 1,500 visitors and thirty-nine exhibitors gave evidence of continually increasing interest in this event, giving assurance to its establishment as an annual exhibit.

WINTER SCENE *by Robert Strong Woodward, c.1940, oil, 39½ x 49 inches, Permanent Collection, SVAC*

At the end of August 1929, the "Southern Vermont Artists" held its annual exhibition in the Equinox Pavilion. This was the first time that particular name for the group had been used. This exhibition, "which has become the leading event not only of Manchester's summer season but of the whole section," included oil paintings, watercolors, lithographs, sculpture, and wood carving. This year's new names included Carl Ruggles, composer and artist, of Arlington, Carl Ramsey, and Cecil Grant. Visitors included a critic from a New York newspaper, a painter from Paris, an old man who put his market basket behind the door while he viewed the exhibition, hotel bell boys during their time off, a golfer, a collector, an English poet, and many children.

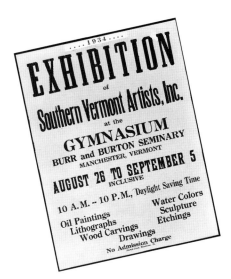

The art critic may well have been Royal Cortissoz who worked for the *New York Herald Tribune* and spent summers at the Equinox House for more than twenty-five years. His abundant praise of the show no doubt played a prominent part in the fame which the Manchester exhibit enjoyed in the New York City area.

In announcing the 1930 exhibit, the *Manchester Journal* said, "The annual exhibit of the Southern Vermont Artists is unique in that there is no charge to the exhibition and no artist is denied an opportunity to enter but is only limited by his residence within a fifty-mile radius of Manchester. The exhibit is now attracting the attention of artists and art lovers all over the United States and the metropolitan papers send art critics to it each year. *The New York Times* recently gave it half a page."

This is the first articulation in print that participation in the annual exhibition was limited to artists living within a fifty-mile radius of Manchester for a part of the prior year. A further dictum was that at least one work of each entrant who had exhibited the previous year would be selected. This was seen as a means of keeping the show independent, representative, and diversified—it would later be dubbed "The Manchester Idea."

The committees had by now been pretty well established. Mary Powers was in overall charge, and the jury and hanging committee comprised Horace Brown, John Lillie, Harriet Miller, Wallace Fahnestock, Herbert Meyer, and Henry Schnakenberg. To David Bulkley, a Manchester photographer, fell the task of receiving and shipping the canvasses. This duty he fulfilled to the satisfaction of everyone for more than twenty years.

Of this 1930 show, one critic said, "Democracy reigns supreme. The exhibition in general shows a love of the subject material and the scene which makes it a welcome relief over many another gallery where stylization and the imitation of the French models has become a bore." Two hundred thirty-five works were shown by eighty-five artists and the small building behind the Pavilion was needed to extend the exhibit space.

By 1931 it was becoming clear that what had started five years earlier as a local event had taken on much wider import. Announced as the Sixth Annual Exhibit of the Southern Vermont Artists, one of the unique features of this particular show was

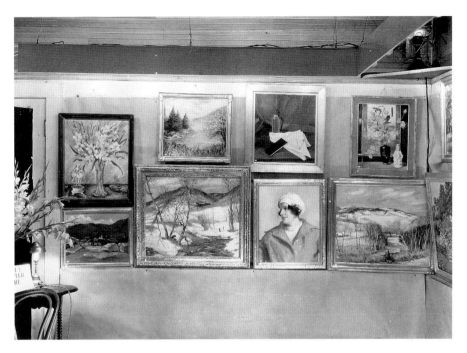

A corner of the 1933 Exhibition of the Southern Vermont Artists held in the Equinox Pavilion

the fact that no fee was charged to exhibitors and no artist or group of artists dominated. So many entries were received that it became evident the jury had to be increasingly selective in order to limit the number of exhibits so that each could be adequately viewed.

The 1932 exhibition was called "the best yet" and the "high spot of the summer season." Over 100 exhibitors showed their work, 3,000 people viewed the show, and sales totaled nearly $2,500—in the depths of the Depression. One of the new exhibitors that year was Luigi Lucioni and one of the highlights of the last day was an impromptu piano concert by Carl Ruggles, Arlington composer and artist. By this time, Hilda Belcher had won the Walter Lippincott Prize at the Philadelphia Academy of Fine Arts, and Edwin B. Child had been asked to show at the Everhart Museum in Scranton. Many of the other local artists were well-known to New York galleries and to metropolitan collectors.

After the show the *Manchester Journal* noted the great educational and cultural value of the art exhibit, to say nothing of its value as a source of publicity for Ver-

mont. "No feature of Vermont life, political or social, is awarded as much space in the metropolitan newspapers." Walter Hard, Manchester poet and columnist and an ardent supporter of the Southern Vermont Artists, expressed the thanks of the community and noted, "one can see what we have felt about the beauty of our natural surroundings." For local residents, the art show was a must-see event.

By 1933 it had become clear that the Annual Exhibition of the Southern Vermont Artists was one of the most important events of the summer season in Manchester—indeed in all Vermont. The fame of artists Schnakenberg, Lucioni, Meyer, Powers, Child, and others was international. The last week in August had come to mean one thing—the SVA Exhibit—and that exhibit was improving in quality each year.

Robert G. McIntyre

A new feature of the exhibition inaugurated in 1933 was the New Collector's Gallery which was initiated to give those with "thin pockets" an opportunity to own paintings. No canvas was priced higher than $25, and the works in this section were smaller works of quality exhibitors.

Among attendees at Mrs. Powers' pre-opening tea that year were Homer St. Gaudens, director of the Carnegie Art Institute, and Robert G. McIntyre, vice president of the MacBeth Galleries in New York, a summer resident of Dorset. One hundred twelve exhibitors from thirty Vermont communities took part in this Eighth Annual Exhibit and four family groups drew particular attention. Herbert Meyer, wife Ann, and daughter Felicia joined newcomer Frank Osborn and his wife Alice Newton, Edwin B. Child and son Sargent, and John Lillie and grandson John L. Davis. The Equinox Pavilion was obviously not large enough to accommodate the growing annual exhibition, and more than 3,000 visitors were admitted in this year of economic uncertainty.

In the interim between exhibits, three paintings from the show were purchased by the Metropolitan Museum of Art for its Permanent Collection: "Winter" by Herbert Meyer, "Still Life" by Luigi Lucioni, and "The Old Factory" by John Lillie. In this time between exhibits, the necessity for formal organization became evident to the members of the Southern Vermont Artists—up until then a casual affiliation of

artists and non-artist supporters—and thus, the Southern Vermont Artists was incorporated by the State of Vermont on December 11, 1933, by-laws were adopted, and officers were elected.

Nineteen thirty-four was a year of firsts. It was the first year that the annual show was held in the gymnasium at Burr and Burton Seminary, and it was the first year of operation as The Southern Vermont Artists, Inc. It was also the first year that Reginald Marsh, vice president of the Art Students' League of New York and husband of Felicia Meyer, exhibited here. Already a well-known and respected artist in New York and Boston, his presence at the Manchester exhibition was widely noted.

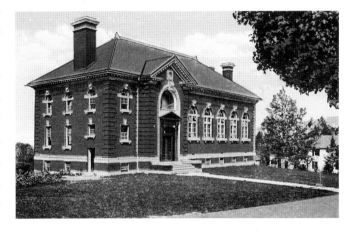

By 1935 it was reported that Harriet Miller had received letters from four artists planning to purchase real estate in Vermont wanting to be sure that they would be within the required fifty-mile radius of Manchester. Three hundred and forty items of the highest quality ever comprised the show, and there were more than twenty new exhibitors. Sales more than doubled over the previous year, and with 539 items and forty-four new artists, space was at a premium even in the new venue.

The old Gymnasium at Burr and Burton Seminary [now Academy], venue for the early Annual Exhibitions

The Tenth Annual Exhibition, August 29 through September 9, 1936, seems to have finally established a dating pattern that is still in use. The 1927 show, called the "Fourth Annual," used 1924 as a starting point. The 1931 announcements were for the "Sixth Annual," using 1926 as the first annual exhibit. Now in 1936, the first exhibit is considered to have occurred in 1926, with the first annual exhibit taking place in 1927. No exhibits were held in 1943, 1944, or 1945 but, after that hiatus, the number sequence picked up without interruption.

In 1936, for the first time, a 10 percent commission was charged on sales with the hope of meeting expenses in this way. New exhibitors included Leonebel Jacobs, Norman Wright, and Stephen Hirsch, head of the art department at Bennington College. His assistant was Francis Colburn, son of former principal at Burr and Burton Seminary, John E. Colburn. Francis went on to head the art department at the University of Vermont.

The fame of SVA exhibitors, assisted by reviews in both *The New York Times* and the *New York Herald Tribune,* was spreading. Mary Powers was exhibiting at the MacBeth Galleries in New York, Wallace Fahnestock was one of five Vermont artists to represent the state at the National Exhibition of American Art at the RCA Building in New York, and Aldro Hibbard was receiving favorable attention.

A review of that 1936 exhibit was headlined "Ten Years of Art in Manchester," and called it the most democratic of all shows in the country. The writer went on to

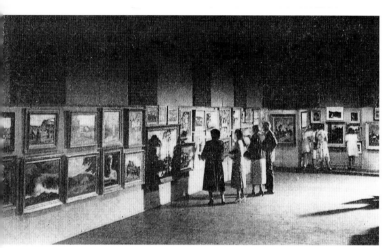

Visitors attending the Annual Exhibition of 1944 when the New Collectors' Gallery debuted at the Burr and Burton Gymnasium

say that here was found not the work of a few prominent artists and their satellites from some art colony, nor a group of pictures shipped from New York. "Here is found artistic expression of both the amateurs and professionals of half a state. Anyone who has for a month during the current year lived in Vermont within a fifty-mile radius of Manchester is eligible. A jury selects the items to be exhibited but each applicant is assured that one piece will be shown. There is no exclusive opening, there is no charge for admission, catalogues are free, there are no prizes or awards—just an art show for everybody."

In 1937, with the approval of Governor George Aiken, the Southern Vermont Artists was privileged to be selected for the first showing of the recently adopted Great Seal of Vermont. The seal is an exact copy of the original, slightly enlarged, as it was designed by Ira Allen of Sunderland. The original cut was made in 1778 by Reuben Dean, a silversmith of Windsor, and adopted in 1779 by the General Assembly, meeting at Bennington. In 1862 a new seal that included Camel's Hump and Mt. Mansfield, and rearranged the original devices, was designed and adopted. The original seal with dies cast by Tiffany of New York was readopted in 1937.

Over 500 visitors a day, a total of over 6,000, viewed the 1937 exhibition which had sales of over $15,000. Galleries and museums from around the country were now sending representatives to the annual show. "Adhering to its principles of democracy in art, there are no prizes, no private openings, and no admission charges. When the show opens, it opens for everyone and it is the sale of art which pays the expenses."

The jury for the 1938 exhibit was selected during the summer and, with 196 artists submitting work, it became necessary to increase the size of the jury. Herbert Meyer, Horace Brown, Wallace Fahnestock, Henry Schnakenberg, John Lillie, Harriet Miller, Robert McIntyre, and F. Clay Bartlett agreed to serve. It was at this time that the term "The Manchester Idea" was coined to express the unique nature of the Annual Exhibition of The Southern Vermont Artists, Inc. Exhibitors must be residents within a fifty-mile radius of Manchester for at least two of the previous twelve months. At least one work from each eligible entrant will be accepted, with a limit of eight, and all work goes to the jury.

A comment made in the *Manchester Journal* ". . . entering the exhibit is like seeing old friends. We see paintings by familiar artists, mostly landscapes of places we know . . ." expressed the feelings of many. Among the nearly 6,500 visitors was a young boy who came alone one morning with his lunch in a paper bag, which he left at the desk. He spent a long time studying the pictures, then returned to the desk and told the clerk he was interested in painting and thought if he could borrow some paper and a pencil he could copy what he'd seen so that he could study. He took time out for lunch and worked all afternoon, then went away without ever being identified.

By 1940 war was raging in Europe and only about 5,000 people attended the annual exhibition. Mrs. Clay Bartlett was in charge and entries were limited in size for the first time. Many people whose interest in art began as viewers were now participants,

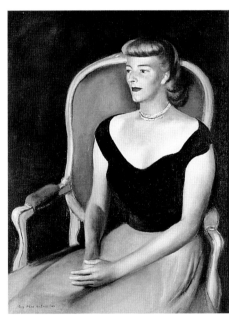

MRS. CLAY BARTLETT
by Guy Pene du Bois, 1948,
40 x 30 inches, oil on canvas,
Gift of Libi Sturges,
Permanent Collection, SVAC

and more and more artists were moving into southern Vermont. In spite of the curtailments of wartime, 900 people attended opening day and purchases were made by museums from Detroit, Brooklyn, and Worcester, and by the Whitney Museum in New York. It was said to be the only show in the country that year where "paintings sold like peanuts." Newcomers included landscapist Dean Fausett of New York, portraitist Orland Campbell, Claude Dern, and Elsa Bley.

In spite of a smaller show in 1941 and a marked decrease in sales, the trustees

voted to hold the 16th Annual Exhibit in 1942. Travel and tourism were greatly reduced by the war but "we cannot abandon our cultural life," declared the committee. Mrs. Bartlett Arkell would raise the necessary funds to mount the exhibit, no catalogs would be printed, and only the first floor would be used for exhibit space. Artists would make posters to advertise the event; only sixty-two pictures were sold and the realities of war were finally faced by Manchester's art community.

After a three-year-lapse, the annual exhibition (the 17th) resumed in 1946. Some 150 artists showed 300 paintings selected by a jury of twelve. Nearly 6,000 people attended and nearly every picture was sold.

Dean Fausett headed the hanging committee in 1947 and introduced a new style to the show. Paintings were hung in groups with open wall space between them. Though the Manchester show had the best attendance of any art show in the east, the results were disappointing. Before much time passed, a new Friends of the Southern Vermont Artists was formed to raise money for better lighting for the shows and to arouse enthusiasm for the 1948 annual show. It was estimated that during its sixteen years of operation 70,000 people had viewed exhibits by the SVA and that over $100,000 worth of art had been sold. In 1948, Dean Fausett headed the jury as well as the hanging committee and was assisted by James Ashley, Herbert Meyer, and Clay Bartlett. Sixty-eight new artists exhibited, and outstanding among the offerings was a portrait of Louise Ryalls Arkell by Orland Campbell. Harriet Miller was experimenting with watercolors, tempura, and pastels after her hiatus during the war.

Nineteen forty-nine marked the 20th Annual Show and would be a banner year for the Southern Vermont Artists, Inc. This was the biggest and most elaborate show ever mounted. It included three paintings by Grandma Moses and, though no one knew it at the time, 1949 would be the last year at the Burr and Burton gymnasium. Excitement built for the big event as one announcement followed another in the weeks preceding the late August exhibit. More than 600 people jammed the opening, and sixty paintings were sold in the first hour! In spite of an excellent hanging job, there simply was not enough space and too much to see—but it was exciting.

Celebration of the 20th Annual Exhibition culminated in a Jamboree on Labor Day at 6:30 in the evening. Everybody (really, everybody) was invited to the Burr and

Portrait of Louise Ryalls Arkell by her son-in-law, Orland Campbell, 1937, Permanent Collection, SVAC

Burton Athletic Field where a buffet supper, square dancing, and musical entertainment were offered. Noted pianist Eugene List (then twenty-nine years old) was a tremendous hit with the more than 1,000 attendees as he played from the back of a truck. President Stanley Ineson awarded prizes for the most popular paintings in the show to Ogden Pleissner, Luigi Lucioni, and Robert Strong Woodward.

Two announcements followed the Jamboree: first, the Southern Vermont Artists would embark on a traveling show. Two groups of forty paintings each would be traveling to galleries in Detroit, Chicago, Omaha, St. Louis, Salt Lake City, Phoenix, Dallas, and Pittsburgh. Any paintings sold would be replaced by items by the same artist. Secondly, plans for a permanent gallery and cultural center were revealed and a major fundraising effort would begin immediately with the artists themselves leading the way. Facilities were planned for symphony concerts, dramatic presentations, and other performances, as well as for solo exhibitions and other shows. Chief among the promoters of this project were Dean Fausett and Herbert Meyer.

Dean Fausett auctions a Norman Rockwell painting during the Southern Vermont Artists' sale to raise funds for a permanent gallery, July 1950

The remainder of 1949 and early 1950 were some of the most exciting months ever experienced by members and supporters of the SVA. The traveling show was being enthusiastically received in every city and seventy Vermont artists were represented. Five hundred people attended an art auction at the Equinox House in June to raise money for a new permanent home for the Southern Vermont Artists. Dean Fausett was the auctioneer and nearly $3,500 was raised with all the paintings donated by the artists.

It is impossible in retrospect to imagine the intensity of effort, the energy, the hours, and the foresight that took a modest organization whose members put on an annual art show, to an association that accepted responsibility for a 300-acre property, built a road, painted and modified the interior of a twenty-eight-room house for galleries, arranged for four concerts and landscaping for an outdoor amphitheater, juried and hung over seven hundred works of art—in six weeks. That accomplishment would change the cultural life of southern Vermont and environs for all time.

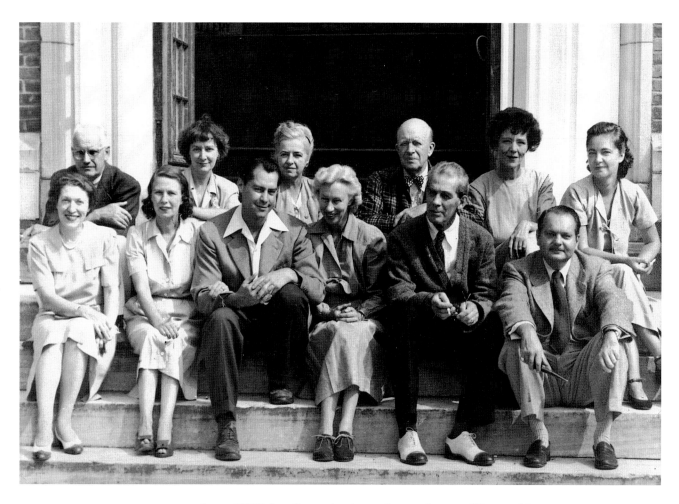

Some of SVA's founding and early members on the steps of Burr and Burton Seminary Gymnasium where annual exhibitions were held for several years, c.1930s. Front: Elsa Bley, Bea Jackson, Dean Fausett, Edith Snare, Wallace Fahnestock, Clay Bartlett. Back: Bob McIntyre, Bernadine Custer, Marion Hughes Barstow, Herbert Meyer, Harriet de Sanchez, Felicia Meyer

Southern Vermont Artists, Inc.

T HE SOUTHERN VERMONT ARTISTS, incorporated on December 11, 1933, held its first meeting on September 22, 1934 after that year's annual exhibition. The by-laws were read and a date was set for annual meetings—as soon as possible after each annual exhibit. The by-laws called for annual exhibitions and required that exhibitors be residents of Vermont for at least one month during the period between exhibitions.

Eleven men and one woman, only one of them an artist, signed the Articles of Association. These incorporators were, variously, the president of the Village and former proprietor of the Equinox House, wealthy benefactor and chairman of the Beechnut Packing Co., Manchester's poet laureate and prominent businessman, president of Factory Point Bank, artist and summer resident, grandson of Robert Todd Lincoln, husband of artist Harriet Miller, prominent Bennington attorney, prominent Dorset businessman and owner of marble quarries, summer visitor, and Bennington County Probate Judge (i.e., Mrs. George Orvis, Bartlett Arkell, Walter R. Hard, William H. Roberts, H. D. Schnakenberg, Lincoln Isham, Harlan Miller, Luther R. Graves II, Ernest West, Edward F. Rochester, and Edward Griffith).

The stated mission of the organization was placed on the record: To promote education and interest in art in the state of Vermont, to hold and conduct exhibitions of paintings, sculpture, and other branches of art, and especially to encourage the study of art in all its branches by the young people of Vermont; to buy, sell, and lease real estate and chattels as may seem necessary.

Attending that first meeting were six members of the Board of Trustees, plus

Judge Edward Griffith

Walter R. Hard

Judge Griffith, Ernest West, Walter Hard, and Herbert Meyer. They elected Robert McIntyre president, Henry Schnakenberg vice president, L. H. Shearman treasurer, and Mrs. Harlan Miller clerk. There were twenty-six members of the organization, twelve of them artists. Members were elected at each annual meeting and, at the third annual meeting of the corporation (Members' Meeting), on September 21, 1936, a record twelve new members were elected: Luigi Lucioni, F. Clay Bartlett, David Parsons, Carl Ruggles, Frank and Alice Osborn, Anne Meyer, Jesse Whitsit, Leale Towsley, Mrs. C. C. deSchweinitz, Redfield Proctor, William Field, and Arthur Gibbs Burton. Only the last three were non-artists. Artist members were required to submit a sample of their work, be nominated, and voted in by their fellow artist members who were often a tough group from whom to win approval. At the Trustees Meeting, L. H. Shearman was elected president. New exhibiting rules coming out of that meeting included a decision that all exhibit offerings would be juried with only three oils per person selected, and a change in the residency requirement was voted. From this time on, those who had resided for two months during the preceding year within a fifty-mile radius of Manchester would be eligible to exhibit.

Before the next year's show, the trustees agreed to invite some artists to exhibit who might not meet the membership or residency requirement. In that group were Henry Schnakenberg (who no longer owned property in Manchester), Reginald Marsh (whose talent and fame were important to the exhibition), Robert Strong Woodward, Luigi Lucioni, Felicia Meyer (married to Reginald Marsh and living in New York), Horace Day, Paul Sample, Andrew and Katherine Butler, and Barney Luntott.

New members elected in 1937 included Mrs. Clay Bartlett, Mr. and Mrs. P. B. Frelinghuysen, Mrs. Edwin LeFevre, Mr. and Mrs. Sherley Morgan, and Miss Mary Porter, all non-artists except for Elizabeth Bartlett who exhibited at the annual shows for many years. The Frelinghuysens were summer residents of Manchester and strong patrons of the arts, Mrs. Edwin LeFevre was a Dorset resident and benefactor, and the Sherley Morgans were Manchester summer residents whose strong support of the

arts benefited the SVA. Mr. Morgan, an architect and professor at Princeton, had built an innovative summer home in the village. Miss Mary Porter had roots in Manchester in the Isham family and had long spent as much time here as possible. Her philanthropy to Manchester cultural institutions was well-known and her devotion to the SVA was unfaltering.

Eleven trustees were elected including Hilda Belcher and Lincoln Isham. Hilda Belcher, an artist from Pittsford, Vermont, had joined the SVA in 1934 and Lincoln Isham, one of the incorporators of the SVA, was the grandson of Robert Todd Lincoln and a resident of Dorset whose interest in and support of the SVA continued throughout his life.

A resolution placing the Southern Vermont Artists, Inc. on record as opposing an increase in billboard advertising in Vermont and a vote to join the Vermont Association for Billboard Restrictions placed the SVA in an active role in the life of Vermont.

As attendance at the exhibitions continued to increase and the numbers of entries grew proportionately, greater sophistication in the organization became necessary. The trustees adopted the idea of a "Museum and Reserve Gallery" in the hope of raising enough money to cover a growing deficit. Rules for exhibitors were printed so there could be no misunderstandings, proper framing was required, and all watercolors were to be under glass. Neither the SVA nor its shipping agent would accept C.O.D. packages.

Ernest West, prominent Dorset businessman and owner of marble quarries

The duties of the Publicity Committee chairman were spelled out in 1938: weekly releases beginning six weeks prior to the exhibit would be sent to listed newspapers, and regular announcements to metropolitan papers would also be sent. During any exhibit there would be no publicity sent out which contained any criticism of artists or their work. All publicity, other than routine announcements, must be approved by any two officers and all publicity was the responsibility of the Publicity Committee chairman (who is encouraged to consult with older and more experienced members).

In the spring of 1939 the treasurer reported that expenses were consistently

*Lincoln Isham, grandson of
Robert Todd Lincoln*

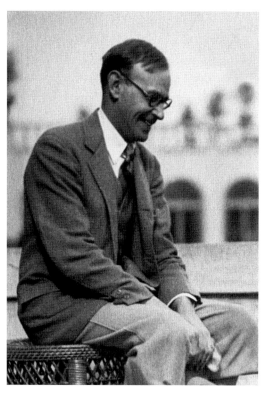

*William H. Roberts, president
of Factory Point Bank
(1935–42) in Manchester*

about 12 percent of sales and, accordingly, the commission on sales charged to the artists was increased from 10 percent to 12 percent. The notification of this decision to the artists included the reservation that should expenses still exceed receipts, further charges, pro-rated, would be assessed to those artists whose work was sold.

The spring director's meeting in 1940 heard the treasurer report a balance of $489 in the bank. Responsibility for raising money to cover any deficit was officially placed with this officer. An abbreviated show would be hung because of the war and a contribution box for the Red Cross would be placed by the door. In spite of the gloom of war, at the annual meeting the treasurer reported sales of $10,863. Nine museums and one institution purchased pictures and Mr. Shearman resigned as president because of poor health. The rest of the annual meeting was deferred until spring.

On January 7, 1941 the deferred annual meeting opened with a tribute to former President L. H. Shearman who had died during the winter. Treasurer Harlan Miller reported a profit from the 1940 show of $237.02 and a bank balance of $731.61.

At the urging of Mary Powers and Horace Brown, the members voted to conduct an exhibition that year, but to discontinue use of the upstairs. Elected were Ernest West as president, Carleton Howe acting treasurer, and eight new members. A limit on the number of members was proposed as well as a method of dropping inactive members.

At the fall meeting Sylvia Wright, sales chairman for the annual show, reported that she had cut expenses to $610.67 and that further cuts could be made. She also suggested that by increasing the membership, income could be increased. When

Mary Powers and Henry Schnakenberg resigned because their properties had been sold, both were voted into Life Membership in the SVA.

Concurrently, the fame of SVA artists was spreading throughout the country. During 1941, seven SVA artists were invited to show their work at an exhibition of American artists in Palm Beach, Florida—Bernadine Custer Sharpe, Harriet Miller, Horace Day, Clay Bartlett, Luigi Lucioni, Reginald Marsh, and John Koch. Others in *Art News* and metropolitan papers included Orland Campbell exhibiting at the MacBeth Gallery in New York, Reginald Marsh at the Rehn Gallery, Paul Sample at the Ferargie Gallery, and Henry Schnakenberg at the Fine Arts Building. Luigi Lucioni had won a prize at the Corcoran Gallery in Washington, D.C., Schnakenberg had done four murals for the post office at Fort Lee, New Jersey, which were now on exhibit at the Art Students League, and Dean Fausett had won the Carnegie Award in the fall of 1941.

Mrs. George Orvis

The acclaim accorded to artists who exhibited in Manchester drew favorable attention to the Southern Vermont Artists as an organization, to its annual exhibitions, and to this area of southern Vermont as an incubator of artistic talent. One of the drawing cards of the exhibitions was the fact that the viewer would see the work not only of well-respected and widely known artists, but the work of friends and neighbors—talented amateurs who were on an equal footing with their more famous fellows.

The raging war in Europe and the Pacific sapped the energy of the SVA and the decision about an annual show for 1942 was a difficult one. Louise Arkell, a new member of the Board of Trustees, argued passionately in favor of holding a smaller show and offered to raise the money to finance it. A month later, at a special meeting, she announced that from seventy-two contributors she had raised over $1,000. Her success in this endeavor would prove to be prophetic.

Only two thousand people attended the 1942 exhibition and sixty-two paintings were sold. Polled by mail, because of wartime travel restrictions, the trustees voted not to have a show in 1943 and to carry over all officers. The same held true for 1944 and 1945.

At the annual meeting held in 1945, twenty new members were accepted, including Dean Fausett, James Ashley, James Montague, Mead Schaeffer, Norman Rockwell, John McCormick, and Orland Campbell. Each of these men would later

Louise Arkell

play a significant role in the future of the corporation. Robert Warner was elected president with Robert McIntyre vice president, Henry Wehrhane treasurer, and Edith Snare clerk. A watershed had been reached, nothing would be the same in the post-war years, but no one knew that at the time.

A turning point for the SVA came in 1946. Unanimously, the trustees voted to hold an annual exhibit, contingent upon engaging professional management. Mr. McIntyre secured the services of Walter Grant with Harvey Stockman as his assistant. They would operate under the supervision of an advisory committee—the Hanging Committee, headed by Dean Fausett. Louise Arkell proposed that Grant be paid only living and travel expenses and Stockman a small salary. Further, she proposed the establishment of the Friends of the Southern Vermont Artists to solicit contributions. These two proposals were adopted and Louise Arkell was named Chairman of the Friends of SVA.

At the annual meeting in September, after a successful show, Louise Arkell reported that $1,333 had been raised by the Friends. For the first time a Nominating Committee was appointed to select trustees from the membership and the number of trustees was increased from twelve to fifteen. The method of selection of trustees and their number would be a matter of bitter disagreement for many years to come. Four Honorary Trustees were elected at this meeting: Ernest West, Judge Edward Griffith, Bartlett Arkell, and Henry Wehrhane. A further amendment to the by-laws was suggested by Dean Fausett—that the residency requirement be increased to three months, as a means of limiting the number of artists and making the annual show more manageable. This amendment was voted. When the trustees held their June 1947 meeting to prepare for the 18th Annual Exhibition, they had a bank balance of $2,915.10. Richard Ketchum was appointed as Director of Publicity at a salary of $200. At the urging of some of the artists, the sales commission was reduced from 12

percent to 5 percent, and prices in the New Collectors' Gallery were raised to $30 with each artist submitting one painting priced at $25. New artists asked to exhibit in the New Collectors' Gallery included Thomas A. Dibble, James Montague, Gene Pelham, and Ogden Pleissner. Inclusion in that gallery was by invitation only.

The trustees were pleased to learn in June 1948 that their bank balance was a record $3,465.91. Total sales from the show were $8,860.50, expenses were $1,577.61, and Friends of the SVA had contributed $1,535. This improved financial picture raised morale among the trustees. Momentum had built for action in obtaining a permanent home for the SVA and the members formed a Building Committee.

Clay Bartlett, whose family were long-time supporters of the Art Center

At the fall meeting in 1949, an undercurrent of excitement pervaded the Members' Meeting as Dean Fausett reported for the Building Committee. The first positive steps were being taken to acquire a permanent home for the Southern Vermont Artists—John McCormick had offered a piece of land for that purpose and Payson Webber, a Rutland architect, had been asked to prepare some preliminary drawings. It really seemed that something was about to happen—exactly what that would be was unclear.

Dick Ketchum remembers the times: "For five years, starting in 1947, I had an advertising agency in Manchester and was working part-time for the SVA as the first paid executive director (the job was simpler in those days, but the title was grand and I was the organization's sole employee with the munificent salary of $1,500 a year— paid entirely by one of the trustees, Gracie (Mrs. Gerard) Lambert.

Detail of SOUTHERN FAIR, *by Clay Bartlett, c.1940, oil on canvas, 33 x 42 inches, Permanent Collection, SVAC*

"For some time Dean Fausett had been talking about the need for a permanent home for the SVA, and one winter when he was vacationing in Mexico I learned that the Webster estate was for sale. I went up and looked at it, liked what I saw, spoke with the realtor, and when Dean called one day from Mexico, I told him about it.

"'Tell them we'll buy it!' he practically shouted. 'I'll head for home tomorrow and raise the money.'

"The price, as I recall, was $22,000 for the magnificent house and hundreds of acres of land. Dean got in touch with George Merck, Gerry Lambert, and Mrs. Barstow, and in what seemed the twinkle of an eye, each agreed to put up one-third of the cost. (Dean was an irresistible salesman with unquenchable enthusiasm.)

"Within a couple of weeks we put on an outdoor goulash of skits, square

Dean Fausett

dancing, singing, and heaven knows what else, all to raise money. What was probably the most important fundraising was done by John McCormick, who took charge of the property's large woodland because of his knowledge of forestry. He realized that no cutting had been done there for years—and should be, so he had a forester mark it for a selective cut, put it out for bids, and lo and behold, the value of the timber was more than enough to repay Mrs. Barstow and Messrs. Merck and Lambert the entire amount they had put up to buy the property.

"It is thanks to Dean Fausett, above all, that we have the lovely site on the side of the mountain. If he hadn't had the vision, seized the opportunity, and taken charge of raising the money to buy it, who can say where—and what—the Southern Vermont Arts Center might be?"

In a momentous decision at the mid-year meeting on June 24, 1950 (after routine matters had been dealt with) the Southern Vermont Artists, Inc. accepted the offer of Henry Flower, Gerard Lambert, and George Merck to purchase the Gertrude Webster estate for $25,000 as the permanent home for the SVA. The property consisted of three hundred acres of land, some woodland, and a twenty-eight-room house. No longer did their duties consist of appointing an overall chairman and chairmen of a jury and a hanging committee, selecting a publicity chairman, and managing two or three thousand dollars. The Trustees were now responsible for this property and its maintenance and its management—and its mortgage.

Now, overnight, they were in big business.

In a series of meetings during July and August the foundations of the newly energized SVA were laid, committees were formed, responsibilities spelled out,

restrictions made clear, and all through this time money was being raised. At a meeting over two days, July 15 and 16, the Trustees voted that: the Southern Vermont Artists, Inc. would purchase from Gerard Lambert the Gertrude Webster estate for $25,000 and a mortgage for $15,000 payable in three years at 2 percent. It was at this meeting that the name "Southern Vermont Art Center" was selected for the new facility. A recent auction of paintings donated by member artists held at the Equinox House, with Dean Fausett as auctioneer, had raised $3,000 and this sum was applied to the mortgage, thereby reducing it to $12,000 even before the ink was dry.

The next task was to form working committees, determine rules of procedure, and areas of responsibility of each committee. Strict lines of authority and channels of communication were established for the Finance Committee, the Property Management Committee, and the Program Committee. Richard Ketchum was hired as Business Manager and Publicity Director and President Ineson was directed to execute the mortgage with Gerard Lambert.

A new chapter in the annals of the Southern Vermont Artists, Inc. was about to be opened and the years of casual involvement in the SVA as a trustee were over. No longer could a trustee expect to attend two meetings a year, one in early spring to make plans for the annual exhibit and one in the fall to receive reports on the annual show, make a few financial and organizational decisions, and vote on new members to the corporation and the board. This was a new era. Membership on the Board of Trustees of the Southern Vermont Artists, Inc. required year-round attention and work. Meetings were needed to deal with the problems of owning property, planning for the future had to be done, there was never enough money, and efforts to raise funds never ended. The Board of Trustees had to be a working board. Major committees were formed and whenever a problem arose, a committee was appointed to solve it. Every member of the board was on at least two committees.

The next years were exciting, frustrating, turbulent ones. Strong personalities clashed, the growing institution made impossible demands, there was never enough money, and still the Art Center grew and grew. There were often misunderstandings between the artists and the lay business people—each wanted what was best for the Art Center but they disagreed about how to achieve their ends.

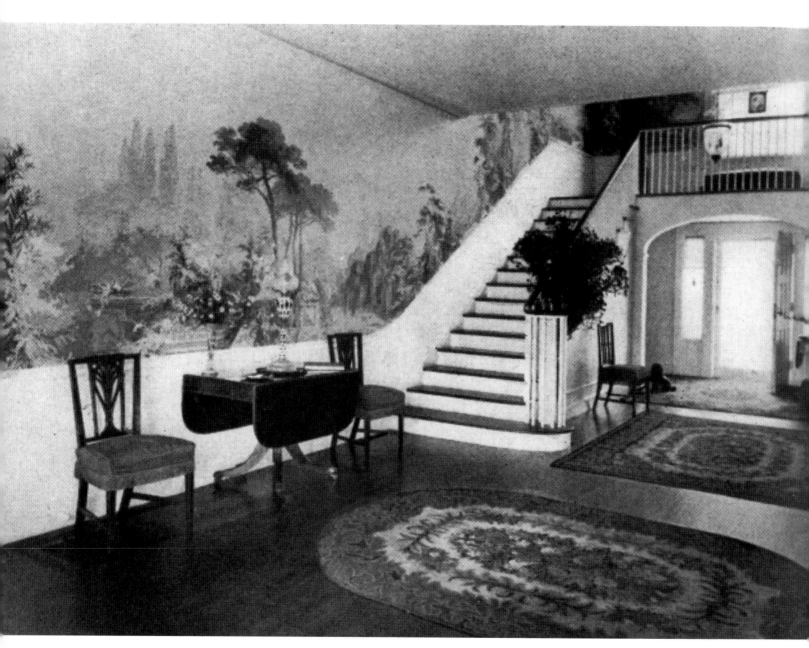

The front hall of the Gertrude D. Webster estate, mid 1940s

Yester House

O N JUNE 24, 1950, THE TRUSTEES of the Southern Vermont Artists, Inc. purchased "Yester House," from the estate of the late Mrs. Gertrude Devine Webster, for $25,000.

When Mrs. Webster died in 1947 she left her Manchester property to the Vermont Historical Trust and provided an endowment so that her glass collection could be open to the public. Legal settlement of her estate put the real estate on the market for $65,000 and sent part of her glass collection to the Bennington Museum. The rest of her china, silver, furniture, and collected items were sold in New York at an eight-day auction with the proceeds going to an Ohio children's hospital.

The real estate consisted of some three hundred acres of land and a twenty-eight-room house situated at the end of a mile-long, winding, uphill drive near the base of Mount Equinox. The property had been farmland from the early days of Manchester's settlement and it is easy to imagine the dense forest that had to be cleared in order to cultivate crops on the lower slopes. In August 1777, General Stark's troops camped at the foot of Mt. Equinox among the springs of Yester House before moving south to take part in the Battle of Bennington. Frenches and Ways and Purdys, old Manchester families, had owned the place at various times, but since 1890 it had been owned by Charles F. Orvis.

An avid conservationist, Orvis had purchased the farm and found someone to operate it while he built fish propagation ponds for the stocking of local streams and to continue his experiments in fish culture. Orvis, of course, was the founder in 1856 of the fishing rod company that still bears his name and which was doing land-office

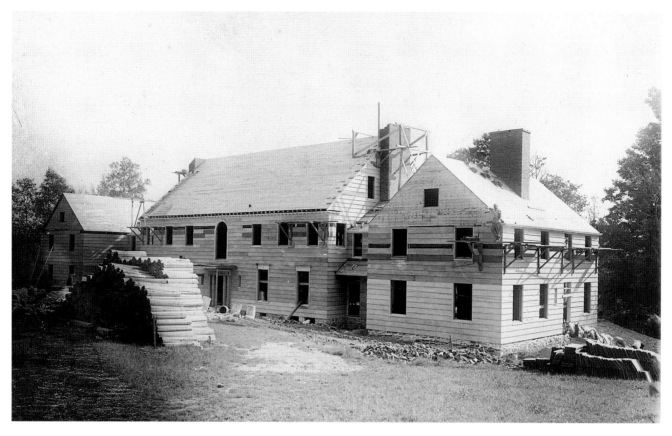

Yester House under construction, 1917. Twelve-inch clapboards were milled on site

business supplying rods, reels, and flies to fishermen all over the world. He believed that the fine fishing to be found in the Battenkill could not continue without strong conservation measures. To this end he supported limiting catches and had been cultivating fish for more than ten years.

The pond near the entry gate to the Art Center was once a trout pond and to the south of the entry road, along the curves, one can still see evidence of three more ponds. They remain as monuments to Charles Orvis' efforts in the field of conservation and fish culture. After Orvis died in 1915, the farm was purchased from the estate, in the fall of 1916, by William R. Ritter of Washington, D.C., as a site for his summer home.

Work on the elegant house, designed by the architectural firm of Murphy and Dana of New York City, began in May 1917. In charge of the building was contractor F. C. Fearon also of New York. The Ritters were in Manchester often during the

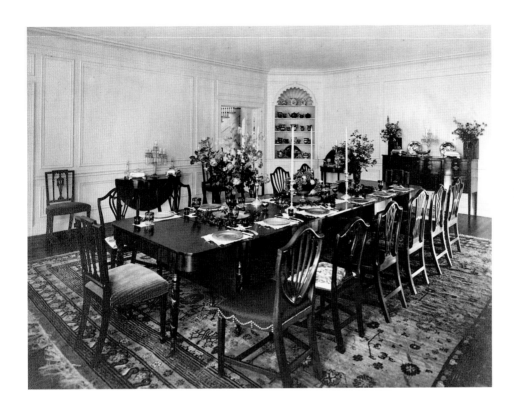

The dining room, c.1919

*Mrs. Webster's writing room,
now the Miniature Gallery*

1917 season, staying at the Equinox House and supervising the construction. In June 1918, they moved into their splendid new house, built at a cost—including land—of about $65,000.

William R. Ritter was a "lumber king" from West Virginia who had made a fortune in that business and was considered a clever and astute business man. His wife, a prodigious collector of art, antiques, and glassware, had amassed the finest collection of Vermont-made glass in existence. In 1922 an article in *Country Life* magazine featured her collection and her article on the history of Vermont glass.

Gertrude Ritter entered the Manchester social scene with enthusiasm and generosity soon after her arrival, and in early September of 1919 opened "Yester House" to the public as a benefit for the Manchester Historical Society. The many art treasures that graced the elaborate mansion proved to be enticing to visitors.

Sometime late in 1923, Gertrude Ritter instituted divorce proceedings against

*Gertrude Divine Webster, left,
and Janet Mulch Janssen
seated in the "Glass Room,"
summer 1946*

William Ritter. The center sections of the metropolitan Sunday papers were taken up with this sensational, scandalous, and highly public domestic matter. She accused her husband of infidelity and of wearing long red underwear to bed, and demanded considerable recompense for her suffering. Final settlement was not made until 1934, over ten years later, as Ritter claimed that the divorce judgment handed down in Washington, D.C., was not valid in his home state of West Virginia, the location of his income-producing property. Finally, he agreed to pay Gertrude $500,000 and to give her the house in Washington worth $350,000, the estate in Manchester valued at $175,000, and a life income of $70,000 a year. In return, he insisted on custody of their adopted son David.

In 1924 Gertrude Ritter married Hugh Webster who gave her adopted daughter Diana his name. The Websters spent their summers in Manchester where Diana had a circle of young friends and where Mr. and Mrs. Webster were a popular couple. They entertained lavishly, spent some time in New York, and left in late December, by special rail car, to spend the winter in California.

Diana Webster, right, adopted daughter of Hugh and Gertrude Webster with her cousin, James J. Divine, Jr., c.1925

In 1925 the Websters added to their estate by purchasing a piece of land across the West Road from the entrance to "Yester House" and a house on 175 acres adjoining the estate to the south. On that property Mrs. Webster settled the Hurds who were caretakers for the big house and grounds. She then left it to them in her will. Many years later the Hurd heirs would offer to sell that property to the Art Center.

During the winter of 1926, Gertrude Webster was ill with flu and pneumonia and discovered that the dry air of Arizona was of great benefit to her respiratory problems; subsequently, the Websters spent part of each year in New York, the summer season in Manchester, and the winter in Phoenix.

Little is known about Hugh Webster. It was said that he was a brilliant and attractive man but that he suffered a breakdown in the early 1930s and spent the rest of his life institutionalized in Arizona. He never returned to Manchester after 1928.

It is easy to picture Yester House as it must have been during the years when the Ritters and the Websters spent their summers here. Fine antiques and art treasures filled every room and Mrs. Webster's stunning glass collection sparkled in the sunlight that streamed through the large windows. The enclosed north pavilion breakfast room housed her 6,000-piece collection of American glass. Called the Glass Room, it was for many years the location of the Artists' Palette restaurant, now called

One of the bedrooms, mid 1940s

Horseback riding trails wound through the woods and fields of the property and the extensive gardens were cared for by four or five gardeners. A housekeeper and several maids lived in the north upstairs service wing while the male employees occupied rooms on the second floor of the garage where there were five rooms and a bathroom. On the first floor was a "Servant's Social Room" for both men and women.

Mrs. Webster's parties were splendid affairs often attended by friends who arrived for the weekend in her private rail car. Fortunate local children who were invited to Diana's birthday parties departed with gifts for themselves.

In August 1940 Mrs. Webster entertained two hundred people to honor her daughter Diana who was attending Louise Homer's summer music school at Lake George. Both Diana and her friends performed vocal music; Mrs. Horace Young and Mrs. George Orvis presided at the tea table. The next year in September, Swiss composer and singer Gustave Ferrari performed at Yester House in a benefit concert for the Kurn Hattin Home—a facility for children in Saxtons River, Vermont.

In an announcement in late 1944, Mrs. Webster let it be known that she wanted Yester House to be a museum under the care of the Vermont Historic Trust. She planned to provide an adequate endowment for its care and wanted the house to be

open to the public. Those plans did not reach completion but some of her wishes were carried out.

Gertrude Devine Webster died in Phoenix in May 1947 and is buried in Sycamore, Illinois, her old family home. Her expansive presence still pervades the Arts Center's hallways and galleries.

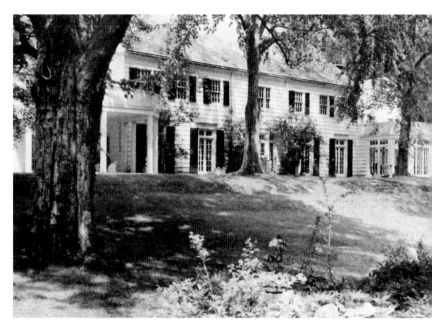

Rear view of Yester House, from the garden

THE FIRST OBSTACLE FACING the Board of Trustees of the SVA on that June day in 1950 was the creation of gallery space, parking facilities, and a concert venue from a twenty-eight-room house and its grounds. Between June 24 and August 26 the monumental task was accomplished.

An army of local carpenters and painters and electricians created galleries out of the gracious rooms, special gallery lighting was installed, the mile-long driveway was widened and resurfaced, and a parking area near the house was created. The exterior of the large house was painted, the brass polished, the terrace trimmed and neatened. A turf platform for the orchestra was created in the natural amphitheater at the rear of the house.

From the beginning, music, ballet, and theater were expected to play a large part in the life of the Art Center. The Program Committee, chaired by Dean Fausett, with Louise Arkell chairing a Music Program subcommittee, announced a four-concert series within a month of the establishment of the Southern Vermont Art Center, and encouraged the purchase of tickets for the entire series. The first concert marked the official opening of the Southern Vermont Art Center on August 26 at 2 p.m. with the Vermont Symphony Orchestra featuring Stell Anderson, pianist, and Alan Carter conducting. Subsequent concerts were given by the Gertrude Barry String Trio; by pianist Richard Gale and Helen Olheim, Metropolitan Opera mezzo-soprano; and by Eugene List, pianist with the Middlebury Composers Conference Orchestra, conducted by Alan Carter. All concerts were in the afternoon in the amphitheater at Yester House.

*The Vermont Symphony Orchestra,
under the direction of Alan Carter,
performs at the opening of the new
Southern Vermont Art Center,
August 25, 1950*

By August 17, the jury for the annual show began its deliberations under the chairmanship of Dean Fausett. In all, 737 works by 286 artists were selected for this 21st Annual Exhibition of the Southern Vermont Artists.

Flowers arranged by Mrs. Stanley Ineson graced the galleries, a beautiful summer day dawned, and at 2 p.m. on August 26, 1950, the Vermont Symphony Orchestra, under the direction of Alan Carter, opened the new Southern Vermont Art Center. When all was said and done, more than 8,000 people attended that first week-long exhibition, 2,000 of them in one day. Total sales exceeded $8,000.

Other improvements to the property and additional festive events came later. In May 1964 the Botany Trail devised by Mrs. Harold Boswell ("Petie") and the Manchester Garden Club was unveiled. With winding paths through the nearby trees and natural terrain, this easily navigated trail takes a visitor into Vermont's native botanical culture. For years, the Botany Trail was maintained and improved by Mrs. Boswell and after her death, in 1996, by the Garden Club in her memory.

The first Beaux Arts Ball in June 1972 was a huge success. It had required an enormous amount of work and planning to create a formal and festive atmosphere, with indoor and outdoor spaces, a champagne supper, and dancing. Tickets were $12.50. Its mission was to unite the Art Center and the community as well as to raise money, and the consensus was that it was successful on both counts—$2,000 was raised.

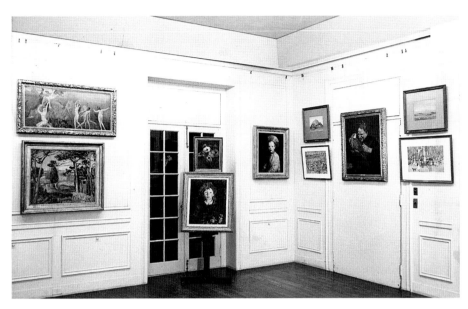

The Beaux Arts Ball continued to be both a financial success and an event that brought the entire community together. One sidelight to the Beaux Arts Ball was entirely unscheduled. At that time the field above the parking lot was fenced off and rented to a local farmer who grazed cattle there. This added a certain ambience to the general bucolic atmosphere of the Art Center. During the ball some attendees, while strolling at the upper reaches of the parking lot for a "breath of air," detected some kind of activity on the other side of the fence. Soon a crowd had gathered and watched in fascination as a cow gave birth to her calf on a beautiful summer night before an appreciative audience—a new feature of the Beaux Arts Ball.

The living room of the Webster estate, transformed into dramatic gallery space

In 1988 Yester House was placed on the National Register of Historic Places.

Yester House is now sufficiently insulated and heated so that it can be used year-round. It was in 1991 that the Art Center operated "on the hill" during the winter months for the first time. Special exhibitions with preview parties have proved to be popular. One such event, "Christmas at Yester House," heralds the holiday season with beautifully decorated trees, wreaths, and gingerbread houses, all donated and all for sale. Proceeds from this event enable the continuing restoration of Yester House's buildings and grounds.

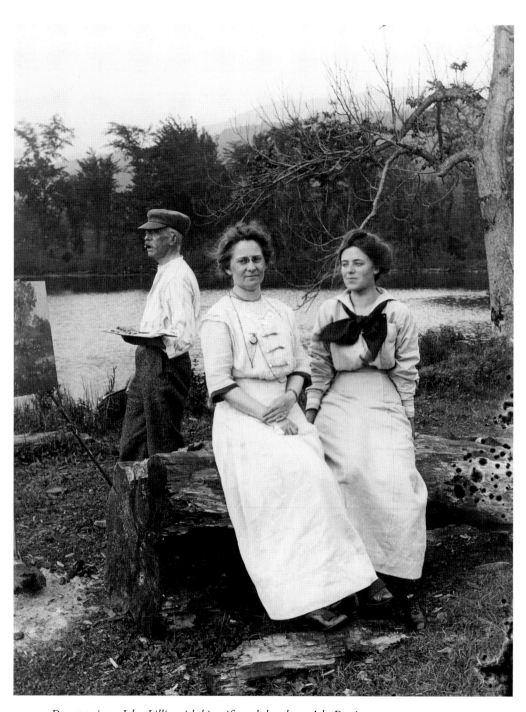

Dorset painter John Lillie with his wife and daughter, Ada Davis, c.1900

The Artists

ONE CAN NOT HELP BUT NOTE the connections between the artists who came to the Manchester-Dorset area to paint—the incidental meetings, the common denominators, the shared friends and acquaintances. In 1871, at the National Academy of Design in New York City, a painting by W. C. Boutelle titled "Mount Dorset" attracted considerable favorable attention. Other artists, seeing his work and that of other Vermont peers, were drawn to the countryside that had inspired such landscapes. Still others were drawn by friends who spent summers in the popular watering spots of Manchester and Dorset, some married local maidens —Edwin Child, for example. An often-listed reference in the biographies of the artists was the Art Students' League in New York. Many of the artists who formed the core of the SVA had studied there, taught there, and exhibited there.

One of them was Henry E. Schnakenberg, a perennial Manchester favorite who depicted the local scene on canvas. The son of Daniel Schnakenberg, a Manchester summer resident, he was a product of the Art Students' League and in 1928 brought friends Harriet Miller and Hilda Belcher to an SVA exhibition. From the earliest days of SVA exhibits, Henry was on the hanging committee and could always be found working behind the scenes to produce a creditable exhibit. He was elected president of the Art Students' League in 1945, and was also a member of the American Society of Painters, Sculptors, and Engravers. His work is in the Permanent Collection of the SVAC and in the Fleming Museum at the University of Vermont, at the Wood Gallery in Montpelier as well as at the Whitney Museum, the Chicago Art Institute, the San Francisco Museum, and others.

Henry Schnakenberg

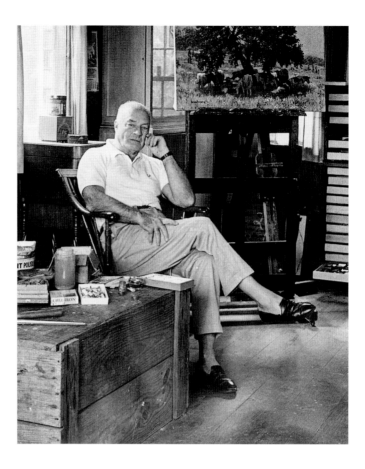

Self Portrait, *by Edwin B. Child, c.1930, oil on canvas*

Harriet Miller (Mrs. Harlan) lived with her husband in Arlington. She was born in Cleveland, Ohio, where she began sculpting at the age of eighteen and then studied in New York. She went to Paris to study and soon after her return she became acquainted with the Manchester show. She was a founding director of the Southern Vermont Artists, Inc. and President of the Board in 1935. She was elected an Honorary Trustee in 1954. In December 1934 a fire in her Arlington studio destroyed all her paintings and sculpture which were stored there. Some of these works had recently been exhibited at the Whitney Museum and at the National Academy of Design. She never regained her enthusiasm for sculpture after the fire and turned her artistic talent to painting, studied under Picard Le Doux, and later experimented with watercolors and pastels. Pieces of her sculpture are owned by the Cleveland Museum, the Whitney, the Corcoran Gallery, the Wood Gallery, and the Fleming Museum, as well as by SVAC. Harriet Miller's involvement and active participation in the SVA spanned more than twenty years.

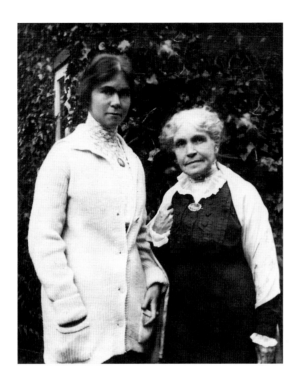

Painter Hilda Belcher and her mother, the artist Martha Wood Belcher

Aurora
*by Harriet Miller,
c.1940, marble,
Permanent Collection,
SVAC*

Hilda Belcher (1881-1963) from Pittsford, Vermont, had studied at New York's Chase School, then in Italy, returning to the United States to teach at the Art Students' League. She had been taught in the Ashcan (realistic) style but taught herself watercolor techniques and perfected that medium. She developed a more impressionistic style of her own as time went on. Her favorite subjects, children and cats, brought her fame and fortune as well as an honorary Master of Arts degree from Middlebury College in 1940. Introduced to the SVA in 1928 by Henry Schnakenberg, a friend from the Art Students' League, she quickly became an active member of the SVA and was a strong supporter and an annual exhibitor for more than thirty years. Her work is in the Permanent Collection of the SVAC and other pieces are owned by the Fleming Museum, the Wood Gallery, by Middlebury College, and Vassar, as well as the Pennsylvania Academy of Art and the Newark Museum.

Jay Connaway (1893-1970) came to the SVA in 1927 from Peru, Vermont. From

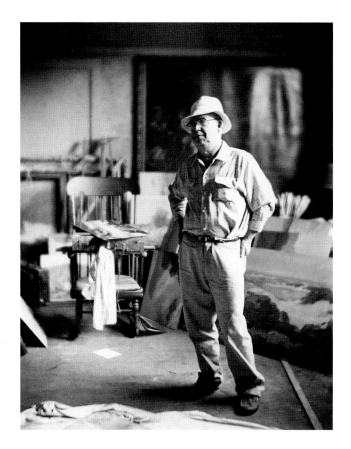

*Jay Connaway in his
East Rupert studio*

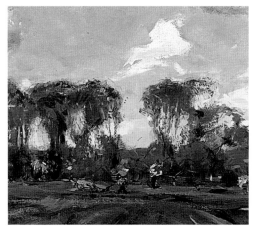

Detail of FALL SKY, PAWLET,
*by Jay Connaway, 1948, oil,
Gift of Louise Connaway,
Permanent Collection, SVAC*

1930 to 1947 he exiled himself on an island off the coast of Maine, conducted an art school on Monhegan Island, and painted the sea. His work from this period is often called "Homer-esque." Born in Liberty, Indiana, he was a student at the Art Students' League and the National Academy and had studied in Paris. When he returned to Vermont, to Dorset and Rupert, he painted Vermont landscapes and founded the Connaway Art School. An effective and enthusiastic teacher, in 1962 he merged that school with the Art Center where he was a trustee and a member of the Art Committee. He had seventy-three one-man shows to his credit and his work is owned by leading museums, galleries, and private collectors, and is represented in the SVAC Permanent Collection. After his death in Arizona in 1970, a retrospective exhibit was hung in his honor at the Art Center.

Carl Ruggles, a native of Massachusetts and educated at Harvard, came to Arlington in the 1920s and first exhibited at an SVA show in 1929. An unconventional man and best known as a composer, his music was described as ". . . bold, mod-

Carl Ruggles in his Arlington studio, posing for his portrait by John Atherton (see Plate 14)

ernistic, full of verve, rich, full-bodied, super-romantic, urgent." It was said that those words also described the man and the paintings that he executed when frustrated with music. At the 1932 SVA exhibit he was the hit of the last day when he sat down at a nearby piano and gave an impromptu concert.

Luigi Lucioni (1900-1988), born in Italy, was a newcomer to Vermont in 1932. He painted in Stowe, Shelburne, and Barre before coming to Manchester for the summer in 1935 and joining the SVA. He first exhibited that year and, accompanied by his sisters Alice and Aurora, made Manchester his home from then on. He had studied at Cooper Union, the National Academy of Design, and the Art Students' League. In 1941 he won a prize at the Corcoran Gallery in Washington, D.C., for a portrait that had been shown at the SVA exhibit in August. Though most famous locally for his paintings of birch trees, his portrait of Ethel Waters won a Carnegie Institute award. He painted very slowly with the result that his output was small compared with many other artists. This factor, coupled with his great popularity, cre-

Luigi Lucioni at his easel, c.1935

Paul Sample, 1959

ated a lively market for his work. He was a kind and charming man who frequently sent Christmas cards featuring one of his paintings to people whose houses or barns he had painted. His contributions to the SVA and to the Art Center are too numerous to mention and his charm and conviviality made him the darling of the local art community. He was a special favorite of Louis Arkell's.

Paul Sample (1896-1970) first exhibited with the SVA in 1934 and his work was always popular with viewers. He depicted the rural scene with accuracy and a special kind of compassion for the human condition. Born in Louisville, Kentucky, and a Dartmouth graduate, he taught himself painting during his recovery from a serious illness, and in the late 1920s, studied in New York and California. He returned to Dartmouth as artist-in-residence in 1938, and lived in Norwich, Vermont. He was a correspondent for *Life Magazine*, and said he turned to painting as a means of communication. One of his biographers says, "He painted the Vermont countryside and people with conviction and understanding and with an affectionate bond with his subjects." In 1960 he was invited to hang a one-man show at the Art Center. His work is in museums all over the country and at colleges as well as in the Permanent Collection at SVAC.

To the SVA came a new means of artistic expression when Ella Fillmore Lillie brought her lithography and her husband Charles to Danby. Born in Minneapolis, she studied art there and then went to the Chase School in New York and to the Chicago Art Institute. In 1938 she chose lithography as her exclusive form of expression. This medium requires eighty separate processes, beginning with a sketch on stone with a grease pencil and ending with inking the stone for transfer of the image to paper. There can be no mistakes, no slips, each move must be perfect, with the result a sharp and clear image.

Lillie's work expresses the tranquillity and serenity of the Vermont mountains and was produced in the basement print shop set up by her engineer husband. One-

person shows in more than fifty cities gave many people the opportunity to see her unique talent. Her work hangs in the Metropolitan, the Boston Museum of Fine Arts, the Library of Congress, the Fleming Museum, and many others including the Permanent Collection of the SVAC.

Clara Sipprell came to Manchester in 1937 with Dorothy Canfield Fisher to meet Sally Cleghorn about whom she had heard a great deal. She found a small house for rent on the West Road and stayed until her death almost forty years later. She was a portrait photographer with an enviable international reputation even then. She was born in Buffalo, New York, and was taught to use a camera by her photographer brother Frank. She studied in New York where she was strongly influenced by Clarence White and by Gertrude Kassebier and began to concentrate on portraiture. In 1920 she had the opportunity to photograph a season at a girls' camp in Thetford, Vermont—she stayed seventeen years. The camp was run by people who had lived in Turkey and later they helped arrange an exhibit for Clara in Constantinople. One of the campers was a Russian girl whose father, a general, had been sent to the United States to buy arms. As the Revolution began, the general was forced to

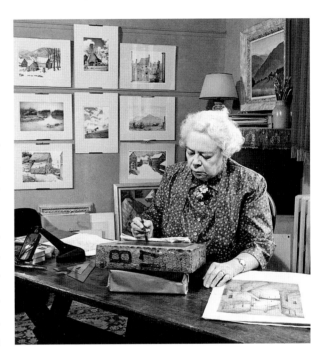

Ella Filmore Lillie

return to his country but left his daughter with Sipprell who had become friendly with the girl. The general later returned to Thetford and, through his influence, Sipprell traveled to Russia to photograph Tolstoy's children, Chekov's wife, Rachmaninoff, and a Moscow theater group. In Thetford, she was helped by John Cotton Dana of Woodstock, who taught her to matte her work and arranged an exhibit for her. As a result of that exposure she photographed the Rockefeller family and Otis Skinner in Woodstock. Her portraits used a "soft focus" technique which produced a personal and ethereal quality that had great appeal. As her fame spread she had shows in London, Paris, and Rome but once she found her house and studio in Manchester, she made it her home. At the Southern Vermont Art Center, the flag

*Photograph of
Malvina Hoffman
by Clara Sipprell*

Clara Sipprell, c.1974

pole in front of the main house was erected in her honor in 1975 after her death earlier that year.

Bernadine Custer Sharpe (1900-1990) lived in South Londonderry, Vermont, with her husband Arthur Sharpe from the 1930s until she died. She studied at the Chicago Art Institute and in Europe and worked exclusively in watercolors. Her illustrations appeared extensively in the *New Yorker* magazine from the 1930s into the 1960s and she had one-person shows from New York to Chicago, Cincinnati to Washington, D.C. Her work can be found in museums including the Metropolitan, the Whitney, the Detroit Institute of Arts and the Wood Gallery, and at Williams College.

Bea Jackson Humphreys at her solo show at the Art Center, 1974

Bernadine Custer Sharpe

As it became evident that war in Europe was a certainty, many artists found refuge in the United States and a stream of new faces came to southern Vermont. Artists among them found a home in the Southern Vermont Artists and were warmly welcomed. Among these was Beatrice Jackson (1905-1991) who was born in London to American parents. She studied in Europe from 1927 to 1939 and won numerous awards in Paris. Fleeing the Nazis in 1940, she went to New York where her landscapes won several awards. She and her husband David Humphreys bought a house in Dorset in 1940 and were elected to SVA membership the next year. Both served as trustees, and David as SVA Treasurer, for more than twenty-five years. David died in 1970, Bea in 1991.

Ogden Pleissner (1905-1983) came to Vermont through his friendship with Robert McIntyre whom he knew in New York. When he was only twenty-seven years old one of his canvases, a cityscape, was purchased by the Metropolitan Museum of Art and he built a solid reputation in New York City. An ardent hunter and fisherman, Pleissner traveled extensively in Scotland, Canada, Alaska, and the western United States pursuing those hobbies and painting people hunting and fishing. He soon came to feel that Vermont was his home and in 1947 built a studio in Pawlet on land he purchased from his friend John McCormick. His ability to take note of every-

Ogden Pleissner at work in his Pawlet studio

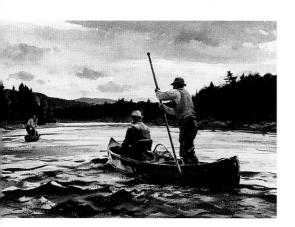

Detail of SALMON FISHING *by Ogden Pleissner, 1970, watercolor, Permanent Collection, SVAC*

thing around him and to put what he saw on canvas produced some captivating hunting and fishing scenes. Primarily a New England painter, his works are in the Permanent Collections of over seventy museums and in corporate collections across the country. He died in London in 1983 and a retrospective of his work was hung at SVAC in 1995.

In 1941 Dean Fausett, James Ashley, James Montague, Norman Rockwell, and Orland Campbell were elected to membership in the Southern Vermont Artists. The significance of their associations with that organization could not have been foreseen. With no exhibits during the war years, the impact of these new members was not felt until after 1945.

Dean Fausett was born in Utah in 1913 and went to New York in 1929 to study at the Art Students' League. After a visit to Vermont in 1939, Fausett was so attracted

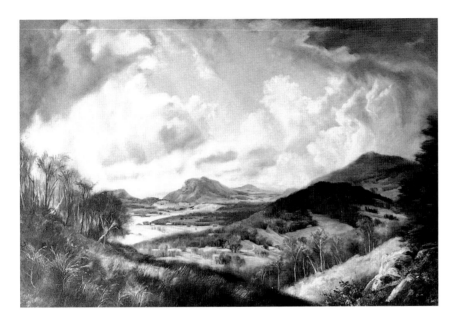

NOVEMBER SKY,
*by Dean Fausett, oil
on hardboard, c.1950,
Permanent Collection,
SVAC*

Dean Fausett

to the local scenery that he returned to Dorset in 1945 to purchase the Cephas Kent Tavern as his home. In 1944 he was named by *Art News* as one of the ten best young artists of the year—in the company of Salvador Dali and Andrew Wyeth. In addition to his landscapes and murals, Dean was an accomplished portraitist and was commissioned to paint the Duke and Duchess of Windsor, Sir Arthur Fleming, and other famous people. His portrait of Grandma Moses was a feature of her 100th birthday celebration.

Dean Fausett quickly made his presence felt as a member of the Southern Vermont Artists. His energy and vision coupled with a driving ability to get things done drew the attention of the organization's leaders and when he was selected as chairman of the hanging committee, he brought a new look to the 1947 annual exhibit. Meanwhile, he was raising money for a permanent home for the Southern Vermont Artists. Working closely with major donors, he and Richard Ketchum together smoothed the way for the purchase of the Webster estate in 1950. Elected as president of the Board in 1958, Dean Fausett forged ahead with new ideas and plans and continued energy, and worked closely for many years with Louise Arkell in rais-

ing money for the Art Center. His vision of a center for the creative arts with emphasis on the encouragement of local talent and the training of young people in art, music, and dance was always before him, and his love and knowledge of music brought that artistic dimension to the attention of the Board. Even in his senior years, Dean Fausett's unflagging loyalty and dedication to the Southern Vermont Art Center have influenced events. His paintings, especially his murals, hang in public buildings in Washington and New York, in Pittsburgh and across the country. Examples of his work are in many Permanent Collections, including that at SVAC.

Jimmy Montague, 1996

James Ashley was a painter of landscapes and a friend and student of Fausett's who developed a close relationship with Louise Arkell and was hired as Director of the Art Center in 1953. He exhibited widely and his work is in numerous private collections. He died in 1999.

James "Jimmy" Montague graduated from Dartmouth in 1928, then studied at the Art Students' League before going to Paris, Rome, Florence, and Venice for further study. Returning to Vermont (where his family had a summer home) after some years in New York, he immediately affiliated himself with the Southern Vermont Artists. During his years in New York he had turned to commercial art as a livelihood but wanted to paint the Vermont landscape. In 1964 he accepted the position of Executive Director of the Southern Vermont Arts Center and brought to that position not only his wide knowledge of art and artists, but his proven administrative skills which were needed at that particular time. He often said that he would talk about art to anybody who would sit still and listen. Standards of excellence in the galleries rose under his leadership and he considered his greatest achievement the re-creation in 1963 of the 1908 MacBeth Gallery exhibit of the Ashcan School. This re-creation was made possible by Robert McIntyre who had shown the original exhibit of "The Eight," knew where the paintings were, and had the clout to obtain them on loan. In 1908, the MacBeth Gallery in New York set the art world spinning when it held an exhibit of The Eight—independent painters who dared to paint what they saw. Their paintings depicted ugliness and dirt, people working at menial sweaty jobs, the back alleys of the city. This was upsetting to an art world of pastoral scenes,

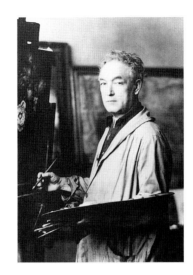

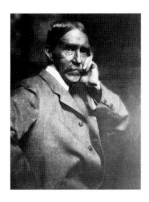

Left to right: John Sloan, William Glackens, and Maurice Prendergast, three of "The Eight"

delicate still lifes, and carefully posed portraits. These eight men—Arthur Davies, William Glackens, Robert Henri, Ernest Lawson, George Luks, Maurice Prendergast, Everett Shinn, and John Sloan—became known, and are still referred to, as the Ashcan School of Art. This show brought national attention to the Art Center and began a tradition of shows by well-known artists.

After ten years of service, Jimmy resigned as Director, but continued to paint and to offer wise counsel to the Board. For many years chairman of the Art Committee, he quietly went about the business of assuring professional competence and emphasizing excellence. He died in 1999.

The entry onto the local art scene of Norman Rockwell in 1941 was significant. He had come to Arlington in 1937 ready to leave New York and the artist colony atmosphere there. He had been creating *Saturday Evening Post* covers since 1916 and would paint over 200 of them in all. Though some people disdainfully called him a commercial artist, his stature among his contemporaries is exemplified by the fact that when his Arlington studio burned, the New York Society of Illustrators contributed the materials necessary to replicate his lost library of collections in the new

studio. He used "real people" as models (Jimmy Montague had posed for him as a boy) and once said, "As long as my fundamental purpose is to interpret the typical American, Vermont is the ideal place, for here are the sincere, genuine, and natural folk I like, as well as like to paint." One of his most impressive and well-known pieces of work, *The Four Freedoms,* was reprinted and used by the Treasury Department in war bond shows all during World War II. Drawn to Arlington by his presence were fellow illustrators Mead Schaeffer, Jack Atherton, and George Hughes, all of whom became members of the Southern Vermont Artists.

Left to right: Gene Pelham, Norman Rockwell, and Christian Schafer under the watchful eyes of Rockwell portraits

Orland Campbell was born in Washington, D.C., and studied at the Corcoran Gallery and at the Pennsylvania Academy of Fine Arts. He gained his reputation with his portraits but later turned to Caribbean seascapes and landscapes. He married Louise Arkell's daughter Elizabeth and spent summers in Manchester where his widow, the late Mrs. Stephen Wilson, resided and his son Orland is a permanent resident. His portrait of Mrs. Arkell is an outstanding example of his work and his portrait of Mr. Arkell hangs at the Ekwanok Country Club. In August 1960 he was invited to hang a one-man show at the Art Center and his work is part of the Permanent Collection there. Other examples of his work can be found at the U.S. Capitol, the U.S. Military Academy, and in many private and institutional collections.

The early 1940s brought the work of Patsy Santo of Bennington to the SVA shows. Born in Italy, he was self taught and had exhibited at major eastern galleries—the MacBeth, Corcoran, and Whitney, as well as in St. Louis and Toledo. Arlo Monroe, originally from Nebraska, studied at the Chicago Art Institute, was a student of mural work and exhibited throughout the midwest. He came to Vermont where he was a teacher of art at Leland and Gray High School in Townshend. Gene Pelham came to Arlington from New York City. He had studied at the National

Orland Campbell, at work on his first portrait of Elizabeth de Cravisto, who he would later marry, 1934

Academy of Design and was a student and intern with Norman Rockwell. He had several *Saturday Evening Post* covers to his credit and was an active and enthusiastic member of the SVA.

When Felicia Meyer, Herbert Meyer's daughter and a painter in her own right, married Reginald Marsh, a serendipitous relationship was created between the SVA and Marsh. Reginald Marsh (1898-1954) was born in Paris and graduated from Yale in 1920. His parents were both artists—his father the well-known muralist Frederick Dana Marsh of Woodstock, Vermont. Reginald taught at the Art Students' League and painted the New York street scene in all its stark reality. He was a welcome visitor at the Meyer home in Dorset but was said to have hated Dorset, much preferring

Left to right: Reginald Marsh—hailed as the modern Hogarth—and his artist wife Felicia Meyer, who inherited the talents of her well-known painter parents, Anne and Herbert Meyer

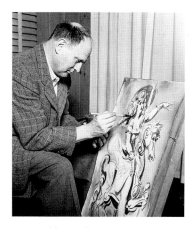

Reginald Marsh

urban New York City. He exhibited at the SVA as an artist member and a major retrospective of his work was shown at the Art Center in 1989.

Harry Shokler, a native of Ohio, made his home in Londonderry. He had studied art in Ohio and Pennsylvania and was an expert in silk screening. His book on silk-screen printing is a definitive work on the subject.

Lea Ehrich (1912-1997) was born in New York City and studied art with private teachers. She married an Arlington lawyer and lived in Arlington from 1945 until her death in 1997. For those fifty-two years she was a member of the SVA, served as a trustee, and was a source of inspiration to many. During the years she was raising her children, she painted prolifically and developed an "ethereal, mystical style of muted palettes charged with bands of color." She continued to draw even after a 1991 stroke left her right side paralyzed. She was greatly loved and respected for her indomitable good spirits and sense of humor, and her death in 1997 was mourned by all of SVA.

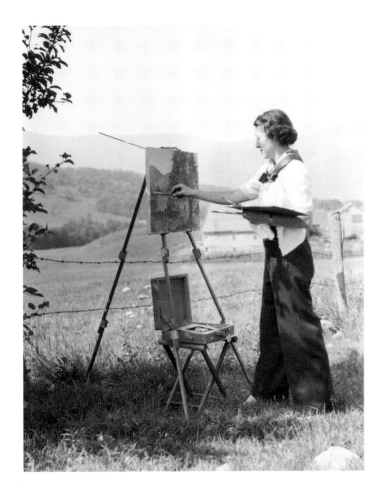

Elsa Bley painting en plein aire, *Dorset*

Lea Ehrich in the library of her Arlington, Vermont home, c.1955

The 1997-1998 Festival of the Arts catalog was dedicated to her and an exhibition of her work was shown in 1997.

Elsa Bley arrived in Dorset in 1945, after studying in Europe and in the United States at the Art Students' League. She was devoted to education and gave classes at the Art Center as well as programs in the schools as part of the SVA's Art Education outreach. When she died, she left her Dorset home and an endowment to the Dorset Historical Society.

Leonebel Jacobs was a well-known portraitist and a close friend of Jay Connaway with whom she had worked in New York for many years before coming to Manchester in 1955. She was a member of the National Association of Woman Painters and Sculptors and had had one-man shows in Peking, Paris, Boston, and New York. She had lived in China both before and after World War II and had painted and exhibited there.

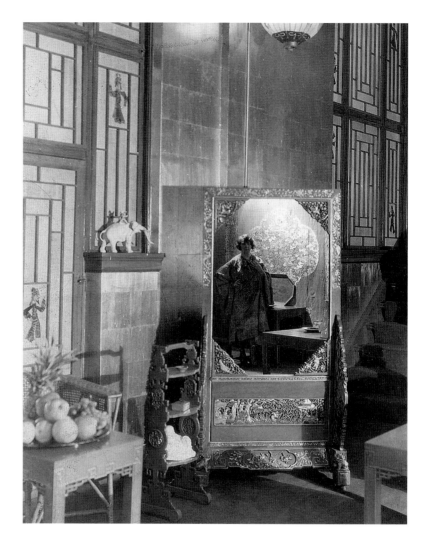

Leonebel Jacobs reflected in her New York studio at One West 67th Street (detail of a photograph sent as a New Year greeting)

Sketch for a portrait of Owen D. Young by Leonebel Jacobs

Born in Tacoma, Washington, Jacobs studied art at the University of Oregon, at the Art Institute of Chicago, and at the Philadelphia Academy of Design. Her poster art promoting the role of women in World War I is on display in the Library of Congress, and during the 1920s, she established herself as a portraitist. During the 1930s and 1940s she joined her attorney father in China, where he represented Sun Yat Sen and where Jacobs came to know and love China and the Chinese royal family whose portraits she painted. Her work is in the permanent collections of numerous institutions, including the SVAC. She died in New York in the 1960s after a brilliant career.

Simon Moselsio, who initiated the first outdoor sculpture show in 1956, was himself a sculptor and a teacher at Bennington College from 1933 to 1960. Moselsio

Moselsio at Bennington College, late 1950s

JAVANESE DANCER, *by Simon Moselsio, sandstone, life-size, 1933, Permanent Collection, SVAC*

first studied art in his native city, Kiev, and at age twenty-one was drawn to Berlin where the Royal Academy of Art welcomed him as a "master student." He and his wife, Herta, were both sculptors of excellence (Herta was also an accomplished ceramist), whose work ranged beyond the human form to animals, birds, and the abstract. They moved to New York City from Berlin in 1924 where Simon quickly began to show his work and teach. The art colony, Yaddo (where he would later serve on the board of directors), offered him space to produce his work for four sessions, and he won recognition as a sculptor before coming to Vermont. He was appointed to teach sculpture at Bennington College (then in its second year) in 1933, where he turned a cement-block chicken house into his studio. He spent the next twenty-seven years in Bennington teaching students how to model in clay, carve in wood and stone, and cast in plaster.

His "Javanese Dancer" is part of the Permanent Collection at SVAC. After his death in 1963, the Fourth Annual Exhibition of Sculpture in the Garden was dedicated to his memory and in 1965 the Art Center held an exhibition of his work. In 1969 the Art Center acquired a collection of the art films of Moselsio, which are of significant importance to the art world as a historical visual record.

Cleade Enders, painter of realistic landscapes and a gallery owner with Anthony

Cleade Enders

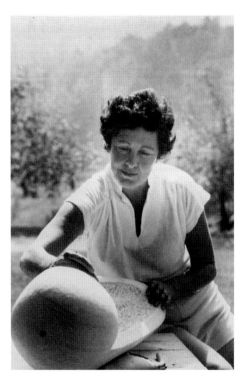

Jane Armstrong

Holburton-Wood, was a frequent SVAC exhibitor. Enders was first introduced to art by the Munson-William Proctor Institute in Utica, New York, but it was only on his return from military service that he began his formal training at the Pennsylvania Academy of Fine Arts, then at the famous Barnes Foundation, and finally at the New York Art Student's League. He has twice won Tiffany Foundation Awards, and has exhibited at the Museum of Fine Arts in Boston, MOMA, at the National Academy of Design, and at the Corcoran Gallery in Washington. He also worked with Louis Bouche on the murals of the Eisenhower Memorial Library.

Cleade first exhibited at the SVAC in 1959. Since then he continued to exhibit at the Art Center annually. After living in New York and London, he moved to Dorset permanently in 1974 where the local subject matter of Vermont skies, old barns, and colorful flower-filled gardens became his trademark. In 1984 he was invited to become a trustee of the Art Center and for several years was co-chair of the Art Committee. He was responsible for the computerization of the Permanent Collection's records and for the construction of the storage facilities for the collection in the attic. And, for the first time, he opened up the outside rotunda facing the building to contemporary art, encouraging artists to exhibit contemporary art in contrast to conventional work and sculpture.

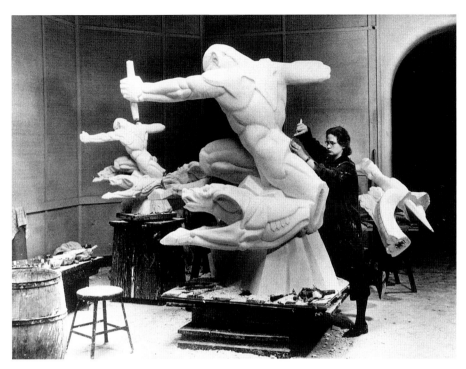

Elfriede Abbe, Cornell University student, working on THE HUNTER, *sculpted plaster, exhibited at the 1939 New York World's Fair*

The sculptor Jane Armstrong began working in marble in 1964 and had her first show in 1966. By 1969 she had won a gold medal for sculpture given by the National Arts Club and in 1970 she gave her sixth one-person show in three years. Her work invites touch and her animal mothers with young have an especially evocative quality. A talented teacher, she has shared her talent in classes held at the Art Center where her husband, Robert, served as a trustee of the SVA. After his death, Jane returned to New York in 1995, but returned in 1997 to continue her work here.

Elfriede Abbe graduated from Cornell University in 1940 as an architect and illustrator. She began coming to Manchester in 1964 as a summer resident and became interested in the Art Center. When she approached Carleton Howe, president of the SVA, about the possibility of teaching printmaking at the Art Center, he was eager to help her and was intrigued with the idea of having an SVA press. Miss Abbe located an old press which Howe arranged to have trucked to Manchester and the classes began. In addition she printed Art Center music programs, posters, and

announcements for some fifteen years. Elfriede Abbe moved to Manchester permanently in 1973, finished her house, and settled in with an old platen press and a letter press to create her classic and specialty books. She also produces wood block prints using the same press and is a talented sculptor. Though she began her career with marble and the human figure, she now works in wood and is especially drawn to interesting wood grains, sculpting mostly animals.

Born and raised in Dorset, Arthur Jones never went to art school. As a boy, all he wanted to do was draw pictures; he found school a monumental bore and his formal education ended after his junior year at Burr and Burton.

Arthur Jones with one of his landscapes

His art education began in the studio of Ada Davis, John Lillie's daughter, who had offered to give him painting lessons on Saturday afternoons with opera playing on the radio in an adjoining room. Thereafter, Jones could often be seen on local roads on his bicycle with his easel and small four- by six-inch canvasses across the handlebars, paint box in the basket, looking for barns and landscapes to paint. When a visitor to Ada's studio admired one of the small paintings, she sold it for five whole dollars. These "miniatures" made up the bulk of his early career—their exquisite detail is a trademark of the Arthur Jones genre.

He first exhibited at a Southern Vermont Artists show in 1948, when he was twenty. Encouraged by James Ashley and Herbert Meyer, Arthur's canvasses grew in size and his prices increased. In 1954, the SVAC invited him to hang his first one-man show. The exhibition netted him $90. Arthur supposed he would continue his primary career as a gardener, but by 1968, a friend advised that it was time to reverse his dual careers to keep up with the demand for his paintings. He set up his studio in one of his farm buildings.

Jones continued to spend a great deal of time at the SVAC, serving on the Art Committee and becoming its chairman in 1972. Young, energetic, and anything but

Jessica Bond

Pam Marron

hidebound, he introduced the idea of "theme shows" to the summer fare with great success. When Jimmy Montague took a leave of absence in 1975, Arthur was asked to be Interim Director. One year of administrative duties with no time to paint was more than enough for him, but he brought energy and new ideas to the position, including that of having hostesses greet visitors to the Art Center, a pleasant tradition continued by volunteers today. When Jimmy Montague retired and Thomas Dibble took over as Executive Director, Arthur gratefully returned to painting.

Jessica Bond of Dorset is one of the leading American authorities in the field of early American decorative design. She was one of only ten people awarded the title Master Craftsman by the historical Society of Early American Decoration. In 1976, she undertook the task of re-creating the old stenciling in the Bennington County Court House in Manchester. That piece of work stands as a testament to her talent and dedication, and enhances the beauty and dignity of the court room in that 175-year-old building.

Ilsley Zecher spotted the work of Pam Marron at her first solo show in 1975 at the Manchester branch of Southern Vermont College. He suggested she come by to

To the Cunninghams Hope your enjoying your painting ↑ Sincerely Pam Marron

visit the Southern Vermont Art Center. Two years later, SVAC was the location of her next show. The Art Center was an invaluable forum for talking and sharing ideas with more established artists who offered encouragement to newer artists just getting their "feet wet." Six solo shows would follow her first show in 1977 for Pam Marron, plus service on the art committee with Bea Humphrey, Churchill Ettinger, Arthur Jones, Jimmy Montague, and Dean Fausett. She won two SVAC Juror's Awards in 1989 and 1998, as well as the Jay Connaway Award in 1987 and again in 1990. In addition, the travel program of the Southern Vermont Art Center expanded her global horizons with trips abroad to a variety of exotic locations, including India in 1998.

Richard Erdman

Internationally acclaimed sculpture artist Richard Erdman grew up in the Dorset–Manchester area. After graduation from the University of Vermont, Richard traveled to Florence and later Carrara, Italy, where he apprenticed to master stonecutters. When he returned to Vermont, the playground of his youth, the mountains, stone quarries, and idyllic settings were his inspiration. As a budding artist, he soon learned how influential the greater Manchester area was for other artists of diversity and renown. The Southern Vermont Art Center, with its standing reputation as Vermont's premier art venue, had long paid homage to such artists as Reginald Marsh, Luigi Lucioni, Ander Knuttson, Sam Ogden, and Jane Armstrong, who was both mentor and friend to Richard Erdman, and always available to lend advice or supplies. His first major exhibition was held at SVAC in 1977. His work is in major public and private collections, including The PepsiCo Sculpture Gardens in Purchase, New York, the Four Seasons Park in Singapore, and Princeton University.

Virginia Webb began her study of art at the age of thirty-one at the Julian Academy in Paris. When she returned to the United States, she studied landscape painting with Jay Connaway and portrait painting at the Art Student's League in

Virginia Webb

New York City, whenever she could find free time from the motel business she and her husband ran in Manchester. Her first award for painting was the Frank Stout Memorial Award from the Berkshire Museum, and in both 1979 and 1980 she won the Jay Connaway Award from the Southern Vermont Art Center, as well as major prizes from such institutions as the Springfield Museum, the Museum of Fine Arts in Springfield, Vermont, and Norwich University. Her paintings are represented in many private and gallery collections. She served as a trustee and a member of the Art Committee of the Southern Vermont Art Center.

These are but a few of the many artists who have been and are members of the Southern Vermont Artists. Their talents and guidance have both enriched and assisted the Art Center, the SVA, and the community in countless and valuable ways. Many names are surely missing—it is not possible to list them all. Their spirits live on and will continue to pervade the Art Center with the richness of diversity.

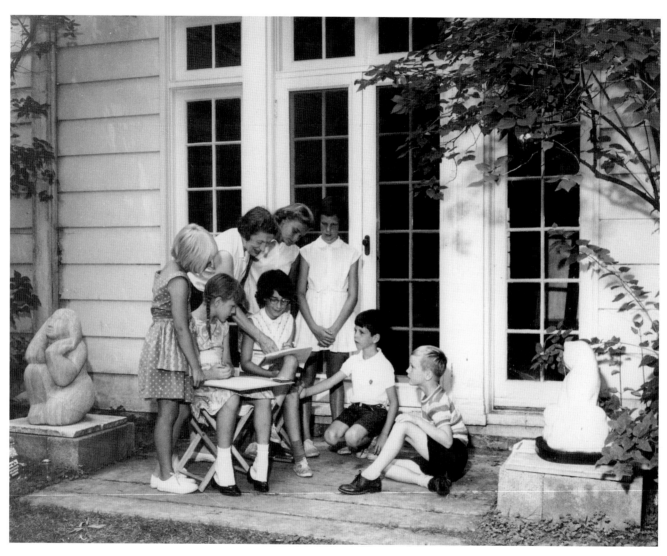

Elsa Bley instructing a summer drawing class of young artists, c.1960

The Artistic Mission

Fʀᴏᴍ ᴛʜᴇ ᴛɪᴍᴇ ᴛʜᴇ ᴀʀᴛ ᴄᴇɴᴛᴇʀ ᴘʀᴏᴘᴇʀᴛʏ was acquired, music was considered an essential part of the overall program. Out of their extensive lists of contacts in the world of performing artists, Louise Arkell and Dean Fausett arranged for three concerts that first year. All were staged in the natural amphitheater at the rear of Yester House where a berm was built to form a platform.

The first of these concerts, on August 26, 1950, the occasion of the opening of the Southern Vermont Art Center, featured the Vermont Symphony Orchestra conducted by Alan Carter with Stell Anderson, piano soloist. This engagement laid the foundation for a continuing relationship with both the Symphony and with Miss Anderson, and for a quality music program for the Art Center.

An added concert that year featured the pianist Eugene List, the young man who had been so popular when he played from the back of a truck at the Jamboree the previous year, and this repeat performance was prophetic.

Dick Ketchum tells the story of the grand day when the house was first opened to the public. Eugene List, the pianist, who was then new to the neighborhood, generously agreed to give a benefit concert and the Vermont Symphony Orchestra was booked to play with him. In those days the VSO was a real pick-up organization: members (who lived in all parts of the state) practiced in small groups with others in their general neighborhood, which might mean that a cellist, a tympanist, and a trumpeter found themselves rehearsing together. Of course, all the players were volunteers.

The SVA had no piano, so Barbara Ketchum loaned her Steinway for the con-

Left to right: Carroll Glenn, Theodore Haig, Mrs. and Mr. Arrau, Marina Svetlova, Eugene List, 1961

cert and with a lot of help everything was set up outdoors in the amphitheater behind the house, with a wooden stage that had been put together and folding chairs. Naturally, it began to rain.

Somehow a group of men picked up the piano and rushed it into the large room inside the house. A huge crowd had turned out and the people had to move inside and spread out into all the rooms in the house. It was hot and sultry. For reasons unexplained, the orchestra took forever to begin. They just kept tuning their instruments.

When questioned, Alan Carter said they couldn't find their tympanist and that their first number was a Grieg piano concerto that opened with the tympany. Where is the tympanist, everyone wondered. Then someone pointed out the window. There, running full tilt down the hill below the amphitheater, shirttails streaming behind in the rain, was a young man—the tympanist, a victim of stagefright.

Alan Carter went over to Eugene List, who was waiting patiently at the piano, explained the problem, and Eugene's face broke into a big grin. He told Alan to begin, and as the conductor lifted his baton, List beat his fists on the piano in the

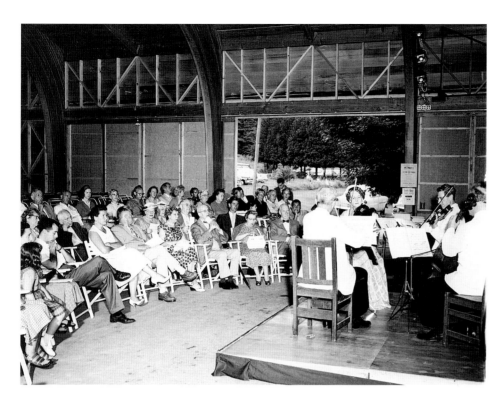

A summer concert in the Arkell Pavilion, 1960

A young dancer rehearses in the Pavilion

rhythm that was supposed to be heard from a kettle drum, and then launched into a glorious rendition of the Grieg piano concerto.

The concert was an enormous success, the first of many benefit performances by Eugene List.

AT ITS MEETING IN SEPTEMBER 1950, the Trustees, aware of the need for shelter for a performing art program, directed the Program Committee to investigate the cost of a Music Shed with a stage, good acoustics, and adequate seating.

The cost of obtaining quality performers could not be met by admission charges alone and the concert programs operated at a deficit from the beginning. A Building Fund was established in 1953 and the first donor was Louise Arkell, who gave $1,000 and also donated $500 to the Music Program. The Trustees agreed to direct monies received from timber sales to the Building Fund.

Serious fundraising and plans for a Music Shed got underway during the latter part of 1954 and in 1955. The firm of Webber and Erickson of Rutland was engaged to provide the architectural plans for a building with a stage and peaks in the arched

*Carroll Glenn and
Eugene List, c.1965*

Rudolph Serkin, 1955

ceiling. The sides were open with sliding panels and there was seating for 300. It was to be located at the south end of the house and its design would echo certain characteristics of the main building. The estimated cost was $40,000.

The 1955 concert series featured Rudolph Serkin, described in one publication as "the greatest living pianist," and there were performances by the popular Village Chorus and the dancers of Martha Howe, assisted by Joyce Hurley. The latter presentation provided its audience with an unforeseen attraction. The choreography called for the dancers, clad in diaphanous garb, to exit the stage (the berm in the outdoor amphitheater) and disappear into the woods beyond. As one of the dancers re-entered the stage, her costume caught on a tree branch and for one breathtaking moment, she was revealed "in all her glory." The need for a shelter had never seemed more urgent.

On July 1, 1956 the Music Auditorium (Shelter) at the Southern Vermont Art Center opened and was dedicated before a huge crowd. The occasion was celebrated with a Vermont Symphony Orchestra concert featuring pianist Stell Anderson on the new stage. Dean Fausett had consulted Dr. Harvey Fletcher of New York to assure the acoustical integrity of the concert hall and the wisdom of this move was borne out when, in 1961, the conductor of the Eastman Chamber Orchestra met the designer of the pavilion and said, "You have given the people of Vermont a really distinguished music building. Seldom has it been my privilege to conduct an orchestra in a music shed with better acoustics—filled or empty, the sound is true." He went on to praise the special arch construction of the roof and the stage construction which allowed both to vibrate and become one with the orchestra. Architect Payson Webber of Rutland and builder Milton Rockwell of Manchester could take well-deserved bows.

Five other concerts made up the music program for the inaugural season; on August 20, one of them featured ever-popular performers Eugene List and Carroll Glenn. When List and Glenn first performed in 1954, it was the beginning of a thirty-

Violinist Carroll Glenn and pianist Eugene List performing at the SVAC

year relationship that would immeasurably enrich the Art Center and the nearby communities. List was born in Philadelphia but grew up in California and made his concert debut December 12, 1934 at the age of sixteen. He studied at the Julliard School of Music and in 1941 enlisted as a private in the U.S. Army and was subsequently sent overseas. Carol Glenn was born in South Carolina and was a student at the Julliard School at the age of eleven. The two met at Julliard and were married some years later. Glenn played a concert in Burlington soon after their marriage and fell in love with Vermont. By 1957 and their third appearance with the Art Center music program, the Lists had secured their place with SVAC. In 1964, Eugene List and Carol Glenn joined the faculty of the Eastman School of Music at the University of Rochester. They had, by then, received international acclaim and brought considerable prestige to the Art Center by their performances here.

Michael Rudiakov (lower left) and Music Festival musicians, 1998

In 1972 the popular pair made arrangements to come to the Art Center to teach and give two concerts a year and, in 1974, they began the program that still brings

master students from all over the world to Manchester for six weeks of intensive study. Weekly student concerts introduced Manchester audiences to a wide range of chamber works and thus the Southern Vermont Music Festival was born.

The popularity of the festival was enhanced by the integration of its students into the Manchester community. Housed in the homes of local residents, the young people became members of the family; practice venues were made available at the Congregational Church and at Burr and Burton Seminary. In addition to the student concerts, faculty concerts on Saturday evenings brought finished products to receptive audiences. Not only were students being educated, all of the Battenkill Valley vibrated to the sounds of stringed instruments.

Louis "Satchmo" Armstrong arriving in Manchester by chartered bus to play at the SVAC July 7, 1958

Shock waves resounded through the valley when news of Carol Glenn's death reached here in 1982, and barely had the art community adjusted to that loss when Eugene List died a few months later. All of southern Vermont was in mourning. Just before their deaths, the Lists had named Michael Rudiakov, world-renowned cellist of New York, as coordinator of the Music Festival. Their work would go on to grow and thrive under his leadership. Now known as the Manchester Music Festival, this institution has found its own place in the area and is highly regarded throughout the world as an educational and cultural program.

The balance between available funds and a quality music program teetered precariously for many years. It is a tribute to all involved that somehow the funds were always found to keep the quality high. New performers were introduced to Manchester audiences, popular music and well-known performing artists were brought to the Art Center stage. Laboring year-round as chairman of the Music Committee was Louise Arkell. It was she who secured the artists and made up the program and she who raised the money for the concert series.

Certain events helped put the Southern Vermont Art Center "on the map." The Music Committee announced in May 1958 that they had engaged Louis Armstrong for a concert in July. Great excitement accompanied preparations for this event for

which special pricing was established, including a $1 charge just to enter the grounds. This was Louis Armstrong's first appearance in Vermont and an auspicious one it was. When the wildly successful night was over, gate receipts totaled $2,735.80—expenses came to $2,740!

Even with such popular concerts, attendance in general was poor and the committee and the Board constantly sought ways to interest the local community in attending concerts on a regular basis. The struggle to keep the Music Program alive went on and on, discussion after discussion took place, and Louise Arkell continued to raise the money needed to keep going. The internecine struggles went on: was this a music or an art center? Which should dominate? Did the Finance Committee have the power to veto Music Committee decisions? Who was in charge? Was opera appropriate at SVAC? Was ballet?

Edgar Salinger, right, holds the rapt attention of Marina Svetlova and Carleton Howe, 1961

Ballet came to the Pavilion in 1960 with the Washington Ballet Company. In 1963 SVAC was selected for the only Vermont appearance of England's Western Theater Ballet. A large and appreciative audience showed its enthusiasm for this kind of artistic expression.

The birthday celebration of nationally acclaimed Grandma Moses in 1960 with the unveiling of Dean Fausett's portrait ushered in a new decade. One of the earliest special exhibits in 1960 featured the work of Gilbert Stuart. Only through the good offices of members known in the art world was the fledgling Southern Vermont Art Center allowed to borrow some of the most valuable and important art in the country.

Grandma Moses celebrated her 100th birthday at the SVAC appearing on the cover of Life *magazine, September 19, 1960*

After James Montague became director, he signed all contracts with performers and would do so only after money had been raised to cover expenses. The trustees agreed to accept donations to fund the construction of public rest rooms in the Pavilion in 1964 and that effort went forward. In 1965 Gian Carlo Menotti's "The Telephone and Pagliacci" was produced on the SVAC stage with the help of Edgar Salinger, a summer resident of Dorset. He was the uncle of Pierre Salinger, President

Kennedy's press secretary, a cellist, and a man who often brought well-known musicians to Vermont at his own expense. His after-concert parties were famous. Through his sponsorship, Manchester audiences heard Rudolph Serkin one night and Mischa Elman the next, and word spread through the music world that the Southern Vermont Art Center was a good place to perform.

THE YEAR 1966 SEEMS TO HAVE BEEN a turning point. The music series opened with the Vermont Symphony Orchestra to a large audience and the Lake George Opera Company's production of "Madame Butterfly" was very well received. The

Eugene List with a student of the Manchester Music Festival's summer program

Pavilion was expanded through Louise Arkell's efforts to include public rest rooms (now required by law) and an attractive lounge area where receptions could be held. A Music Fund had been established and in 1968 it amounted to $25,000, all raised by Louise Arkell.

Louise Ryalls Arkell died in December 1969 and on Sunday, June 28, 1970 a memorial concert in her honor dedicated the Louise Ryalls Arkell Pavilion at the Southern Vermont Art Center. Contributions declined for a time after her death, the Music Program underwent serious evaluation, and the Board of Trustees and the Finance Committee required that all committees submit budgets and operate within those budgets. Rental fees were charged for use of the Pavilion and care was taken to maintain the high quality of performances at the Art Center. Even those events not part of the Art Center program were scrutinized for content and quality.

The 1970s brought new enthusiasm for the music program as the List/Glenn Music Festival came to the Art Center. Performers were asking permission to perform here, audiences increased in number, and the trustees again articulated their philosophy that, in spite of any financial losses, the continuation of a strong music program was a part of the stated mission of the Southern Vermont Artists, Inc. and, further, went on record as considering any shortfall between income and expenses a gift to the community.

Funded entirely by sponsors, The Newport Jazz Festival All Stars came to the Art Center in 1972 to a sold-out crowd of over 350. The Music Program had many

Student art exhibited at the SVAC

strong advocates, not the least of whom was Stell Anderson, who had first come to the Art Center as a piano soloist with the Vermont Symphony Orchestra in 1950. She had been a member of the Board of Trustees for many years and was an outspoken advocate of the Music Program.

Meanwhile, education had not been neglected. Richard Gale, a pianist who had performed in the first SVAC concert series, asked permission to give lessons at the Art Center in 1951. Jay Connaway was giving Saturday art lectures to eager and appreciative audiences and an art school was under consideration. Gene Pelham asked to rent the loft in the garage for classes two days a week at a fee of $15 per month. By 1957

Children's theatre class, mid 1970s

children's art classes had been established. In 1958 Jay Connaway and Edgar Salinger proposed an art program for the Art Center consisting of six lectures at a cost of $350. The Trustees accepted the proposal of what became a popular series, considered an important device for getting people from town up the hill.

By May 1964 all the art classes were fully subscribed, scholarships were available for needy students (thanks to a $600 fund which had been solicited), and space

SVA sponsored the Hartford Ballet Company's performance of the Nutcracker *at the Manchester Elementary School, 1965*

became an urgent problem. The efforts of Jimmy Montague's outreach in area schools seemed to bear fruit when Burr and Burton Seminary hired an art teacher in 1968. A children's three-week music education program was initiated in 1972.

The art classes were oversubscribed and the space was seriously overcrowded but it was hard to turn people away. In 1967 the second floor of the garage was converted to studio space and the roof was raised to let in more light. The first floor was made into a sculpture studio and photographic dark room. The List/Glenn music school begun in 1972 was met with overwhelming enthusiasm. The presence of young musicians-in-residence studying under master musicians brought a new dimension to the art atmosphere at the Art Center.

To remove the feeling of isolation from the community that seemed to exist,

every effort was made to include local residents in activities going on at the Art Center. By orienting art, drama, music, and dance classes toward children, by initiating special school tours of the galleries, and by giving school slide lectures and classes on great plays, the hope was that more and more people would feel comfortable "on the hill."

A captive audience of community children enjoys the Nutcracker Ballet *in the gymnasium of the Manchester Elementary School, 1965*

Dance, always a part of the performing art program beginning with the Martha Howe group, continues to be of interest to the modern SVAC. Svetlova's dance classes began in 1960 and continued sporadically into the 1990s when she ceased operation of her Dorset dance studio. The Joyce Hurley dancers brought local performers to the Art Center stage during the 1960s and there was a short-lived attempt to start an SVAC ballet school in 1974 in connection with Castleton State College. The

dancer and choreographer Rachel List conducted a dance school for some years, and the Manchester Ballet was a going concern until 1997, though not connected with the Art Center.

Theater in various forms—skits, one-act plays, reviews—have found favor on the SVAC stage but the renowned Dorset Theater has so successfully filled that niche that no concerted effort has been made to begin a special drama program.

Sculpture was part of some of the early SVA exhibitions and in 1952 sculptors were especially invited to exhibit at the Art Center and to consider adding works to the outdoor display now called the Sculpture Garden. Indicative of the early respect enjoyed by the Southern Vermont Art Center, the New England Association for

Contemporary Sculpture offered to exhibit here as early as 1952. In 1956 Simon Moselsio, a well-known sculptor then at Bennington College, asked permission to show his work in an outdoor exhibit at no cost to the Art Center. Taking advantage of spaces in the lower meadow and along the winding entrance drive, on the lawns and in the gardens, the Sculpture Garden features the works of well-known sculptors and provides a venue for displaying works from the Permanent Collection. Stone, wood, and metal are represented in these changing exhibits and each year some new and innovative piece of work is displayed in the circle in front of Yester House.

Filmmaker Frank Capra and the 1974 poster announcing his appearance and film screening at the SVAC

The SVAC Film Festival, begun in 1970 as a way to build and sustain interest in the Art Center, particularly during the winter months, was the brainchild of Wini and John Hawkes, who were helped immeasurably along the way by Margaret Pierce. Lord Kenneth Clark's series "Civilization" was the first series in the program, "a non-profit community venture sponsored by the Southern Vermont Art Center" held at the Manchester Cinema. A Greta Garbo series followed that, and then came the International Film Festival, held for the first time in the Arkell Pavilion. The open-

ing film, "Around the World in Eighty Days," filled the 450-seat Pavilion and 200 people had to be turned away. In October 1974, the Hawkes were able to lure legendary filmmaker Frank Capra and his wife to the Art Center from California to be guests-of-honor at the highlight of the film program, the Capra Festival, which showed Capra's personal favorite, "It's A Wonderful Life" and "Mr. Smith Goes to Washington.'"

The Hawkes started a Film Library for the Art Center hoping that classic cinema had a place in the overall mission. It did. Later, David Bort took over the job of projectionist, and black-and-white vintage films were shown during the winter months on Sunday afternoons at the local movie theater.

By 1997, courses and workshops numbered more than thirty for both children and adults. Presented by qualified instructors, the subject matter ranges from life drawing, oil and watercolor techniques, and sculpture to flower arranging for adults. Children's classes run the gamut from drawing to mask making, puppetry and totem poles to dinosaurs and robots. The buildings are crowded with people—people learning, people listening, people looking.

One of many popular painting classes held in the carriage house

Mr. and Mrs. Bartlett Arkell,
c.1930

Patrons and Supporters

Through the ages, artists have depended upon patrons to support their pursuit of the creative Muses. Although such patrons have played a part in the successes of the Southern Vermont Artists, Inc., the people included in these pages have been much more than patrons of the arts.

The alliance of artists and their supporters that resulted in the formation of the Southern Vermont Artists, Inc. has continued to be one of the strongest such coalitions known in the art world. It was the strong union of talents and resources that produced art shows each year in Manchester, that dared to accept responsibility for the purchase of a large house and adjacent real estate, that has labored to raise money, to encourage new artists, to educate the young, and to fulfill its stated mission.

Robert McIntyre, a Dorset summer resident, was the retired director of the prestigious MacBeth Gallery in New York and the first president of the SVA after incorporation. An authority on 19th-century art and an avid collector, Robert McIntyre was of enormous help to many struggling artists. He used his New York contacts to arrange for the work of unknown painters to be shown. His leadership, wisdom, and experience were invaluable to the organization and his election as the first Honorary Trustee in 1953 showed the appreciation the membership had for his efforts. Before his death in 1965, his greatest coup for the Art Center was the exhibition of "The Eight"—a replication of the spectacular 1908 MacBeth Gallery exhibit of the Ashcan School painters. This event brought a great deal of attention and acclaim to the Art Center.

From its first show until 1950 when he became too ill to continue, David

*Mr. and Mrs. Robert G. McIntyre
at "The Eight" Exhibition, 1963*

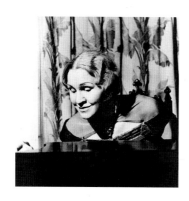

Stell Anderson, pianist

Bulkley was a linchpin in the conduct of the annual exhibits of the SVA. It was he who received the art work as it poured into Manchester, uncrated paintings and sculpture, and delivered them for the jury's consideration at the proper time. It was he who painstakingly repackaged and returned rejected work, promptly shipped paintings purchased at the show, and sent back the paintings remaining after the exhibits were over. There was never a single complaint during all those twenty years. A Manchester native and photographer, Bulkley died in Oregon a few years after leaving the SVA.

Strong supporters of the artists of southern Vermont in the early days were Mrs. George Orvis, proprietor of the Equinox House and Manchester Village leader, drugstore owner and poet Walter Hard, and Probate Judge Edward Griffith. These people used all the influence at their command to win financial support for and interest in the annual exhibitions. Lincoln Isham, grandson of Robert Todd Lincoln, Ernest West, owner of marble quarries and apple orchards, and L. H. Shearman brought support from Dorset.

In 1920 Bartlett Arkell of Canajoharie, New York, purchased the Manchester estate of Henry W. Brown, just north of the entrance gate of the Ekwanok Country Club, and with grounds abutting that famous golf course. Thus began an association with Manchester, its affairs, and its art community that went beyond support. Arkell was president and partner in the Beechnut Packing Co. and a community leader in Canajoharie, where his philanthropies—including an art gallery and a library—and his interest in making his city aesthetically pleasing led him to underwrite several beautification projects. The Arkells entered Manchester's summer social life with enthusiasm and became members of the Ekwanok Country Club. Mrs. Louisiana Arkell died at her home here in 1927 and Mr. Arkell spent the next year in Europe. In 1929 he married Louise Ryalls Craviato in Paris. The new Mrs. Arkell was a well-known patron of the arts in New York, a member of the New York Philharmonic Society, and a fundraiser for the Guggenheim outdoor concerts.

Bartlett Arkell was one of the incorporators of the Southern Vermont Artists in

1933 and an avid collector of art. His support of the arts was unfailing, and his death in 1946 at eighty-five was a blow to the entire community.

Louise Ryalls Arkell was an artist of no little talent in her own right and she threw herself enthusiastically into the activities of both the SVA and the Garden Club. Her indomitability in the face of great odds has made her name legend in Manchester. The story is told that one year when she was in charge of the Garden Club Flower Show at the Burr and Burton Gymnasium, the displays of flowers were to be centered on a large water wheel. When the time came to arrange the show, the wheel would not fit through the gymnasium doors, so Louise Arkell ordered the doors removed—the show went on as planned. It was she who raised the money so that the 1942 annual art exhibit could take place—in fact she raised three times the amount set as a goal. After World War II, she organized the Friends of the Southern Vermont Artists to support the exhibitions which were becoming increasingly expensive to mount. When the Webster estate was purchased in 1950, Louise Arkell was one of the SVA trustees who worked to make it possible. Her advocacy for the Art Center went on undiminished until her death in 1970 at the age of eighty-four.

A graduate of Smith College, Louise Arkell taught Latin, French, and English at the American School in Mexico City and there she married Carlos Cravioto in 1908. A daughter, Elizabeth, was born to them and later the couple divorced. In 1912, Louise returned to the United States and became a fundraiser and a champion of artists who often urged her husband to buy the paintings of unknown artists at generous prices to bolster their value. At Smith College she had not been allowed to study art and music except as extracurricular subjects, though both had been great interests of hers. She indulged these interests by learning all she could about them and by learning to draw and paint. One of her favorite fundraising techniques was to give a dinner party for prospective donors and then to encourage competition among them to give the most.

Mrs. Bartlett Arkell, left, receiving certificate of thanks for her 25 years as chairman of the Student Ticket Endowment Fund of the Philharmonic Symphony Society of New York, October 27, 1948

In 1962 the Arkells were honored at the opening concert of the New York Philharmonic. For thirty-five years, Louise Arkell had arranged for public school and college students to attend concerts at Carnegie Hall at reduced prices and Mr. Arkell, with a large gift, founded an endowment fund for that purpose. At the Southern Vermont Art Center, the Louise Ryalls Arkell Pavilion, dedicated in 1970, stands as testimony to this woman's tenacity and devotion to the institution she loved so much. The Arkell Endowment Fund keeps alive memories of these two people who never stopped giving.

Richard Ketchum

Royal Cortissoz was one of the most influential promoters of Manchester's Southern Vermont Artists' exhibitions. He was art editor and critic for the *New York Herald Tribune* beginning in 1891 and began visiting the Equinox House in 1924. He was so favorably impressed by the early art shows that he arranged to return to Manchester each August and his favorable—even glowing—reviews did much to establish those early shows as worthwhile events in the minds of metropolitan audiences. He also wrote for *Scribners* and mentioned Manchester and its art exhibitions in that publication. When he died in 1948, at the age of seventy-nine, members of the SVA mourned the passing of an era and the loss of a loyal friend.

Sketch of art critic, Royal Cortissoz, by Leonebel Jacobs

Richard Ketchum came to Manchester in 1945 from service in the U.S. Navy and became office manager for the C. F. Orvis Co. In 1951 he opened his own advertising agency (his father owned an agency in Pittsburgh) and was generous in providing help to non-profit organizations, especially the SVA. Like a number of artists and supporters of the SVA, he lived in the Dorset-Pawlet area and came to know a coterie of people whose expertise, talent, and energy made the Southern Vermont Artists the driving force that it was. Hired as publicity director for the annual show in 1947, in 1949 he and Dean Fausett put together a highly successful traveling show which took some forty paintings to galleries in Detroit, San Francisco, Dallas, St. Louis, and Cleveland.

He was instrumental, along with Fausett, in negotiating the purchase of the

Webster estate by Gerard Lambert, George Merck, and Henry Flower. Working behind the scenes as a paid employee and as a trusted advisor, Dick played a vital role in the early years of the Art Center. His knowledge of marketing and advertising kept the Southern Vermont Art Center sparkling in the public arena and drew people to its doors. Called to return to his country's service in 1951, he held a position with the Department of State in the Internal Information section of the Public Affairs Division. His interest in history took him to *American Heritage* magazine where he met William Blair, who joined him in publishing the renowned magazine *Country Journal* (then based in Manchester) during the "back-to-the-land" movement of the 1970s. A respected writer of Revolutionary War history, Richard Ketchum now divides his time between his Dorset farm and a new home in Shelburne, Vermont.

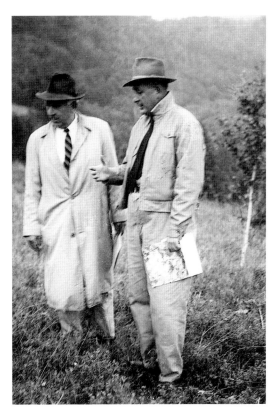

George Merck, holding map, discusses management of the Merck Farm

The men who made possible the purchase of the Webster estate were interested in supporting the art and eager to be helpful in creating a cultural center in the Manchester–Dorset area. Gerard Lambert was a New York banker and, once the offer of $25,000 for the Webster property was accepted, it was he who personally negotiated a loan for that amount at a New York bank. Surprised when the loan was repaid by the SVA, he said it was the first time he had ever been paid back for that kind of loan. Henry Flower had retired to Manchester and was a neighbor of L. H. Shearman. He was the first president of the Manchester Village Association and deeply interested in the betterment of the Village. George Merck, head of the Merck pharmaceutical company and founder of the Merck Forest Foundation in Rupert, was, in addition to being an early and ardent conservationist, a long-time supporter of the art as was his wife. For the rest of their lives, these three men were most generous with all kinds of assistance during those precarious early years of the Art Center.

Mr. and Mrs. John McCormick, Jr.

Carleton Howe

In 1945 John McCormick, Jr. came to the Pawlet farm he had purchased just before World War II. He had left a banking career in Pittsburgh for the hands-on outdoor life he preferred, and he operated a dairy farm and wood lot in Pawlet for some years. He and his wife "Bird" had arrived at about the same time as a number of other "refugees" from urban life and their paths crossed and intertwined. Many of the McCormick's friends were artists—the Meyers, the Pleissners—and the Ketchums were also friends. Membership in the SVA was a natural extension of those friendships. So it was to John McCormick that Dick Ketchum turned when problems arose concerning the Webster estate and the possibility of acquiring it for a cultural center. When the Webster property became available he gave good advice to the men who were considering whether it was a sound purchase. As cream rises to the top, it seemed natural to ask John McCormick to head the new Property Committee—he was a man who knew how to get things done. A lover of trees and forests, he had taught himself to identify trees, to estimate timber yields, and to manage timberland. He and William (Bill) Meyers, George Merck's forest manager, cruised the SVA timberland on the slopes of Mt. Equinox, identified every tree, tagged those to be harvested, and estimated the yield. What's more, they

devised a cutting plan that would produce income for years into the future (and is still doing so). This plan is considered one of the outstanding examples of forest management in the state and foresters from all over Vermont come to study it. Elected president of the SVA in 1951, McCormick served for two years and for several more on various committees and in an advisory capacity.

At a time when youth and daring and energy were needed, it was abundantly available to the SVA in such people as Dick Ketchum, Dean Fausett, and John McCormick, among others. But the wisdom of seasoned warriors was also both welcome and needed for balance.

Carleton Howe joined the SVA in 1941. His Chicago family had owned a summer home in Dorset Hollow for years and he returned in the 1920s to join his father in a maple sugaring and lumber business in Dorset. A true Renaissance man, he was a farmer, apple grower, senator from Bennington County, and patron of the art. He was a founder and first president of the Vermont Council on the Arts, founder and board member of the Vermont Academy of Arts and Sciences, trustee and president of the Vermont Symphony, and a trustee of Vermont Public Radio, trustee of the Factory Point National Bank, and of Burr and Burton Seminary. He served on the board of the SVA as its acting treasurer in 1946, as president from 1961 to 1970, and as a trusted advisor until his death in 1993 at the age of ninety-five.

Carleton Howe discusses the printing of a poster with Elfriede Abbe at the SVA press, 1966

Known to everyone simply as Carleton, his attention to financial matters and insistence on adherence to the budget made him a strong chairman of the Finance Committee. He deplored the deficits which had to be covered by the sale of paintings—a Grant Wood given by George Merck, for instance, that should have been made a part of the Permanent Collection. The early 1960s were very difficult—there were times when it did not seem possible that the Art Center could continue—but the faithful labored on. Though he resigned in despair in 1963, his resignation was not accepted and the SVA members vowed to work harder. Things did improve.

Left to right: Gene Pelham, Carleton Howe, Ilsley Zecher, and Dean Fausett at the Art Center's 50th Anniversary celebration, 1979

Jimmy Montague used to tell the story of the deplorable condition of the road leading up to the Art Center. There was no money for the expensive repaving work that was needed but complaints were heard daily. When the Village road crews began their rounds patching pavement in the spring, Carleton followed them, stopping to beg for "just a bucketful" of their hot mix. With the coveted prize in his car, he attacked the worst spots with a small shovel and his patching mix, hoping to hold back the tide for another day.

A newsletter, *The SVA Artist,* was Howe's inspiration and served to keep all members and friends aware of activities at the Art Center and the needs, financial and material, of the organization. By the time he retired in 1970, the financial affairs of the SVA had improved and he had safely guided the organization he loved through perilous times. His home on the West Road served as the SVA's winter headquarters for a number of years before it was possible to stay at home on the hill during the winter months. When he died in 1993, Manchester and its environs mourned the passing of an era and the loss of a friend and leader.

Ilsley Zecher was the only SVA president to serve a ten-year term. He had come to Manchester in the 1950s to establish a dental practice and was drawn to the Art

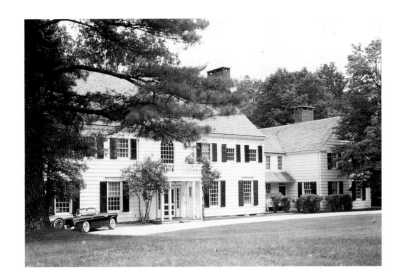

Yester House as it appeared in the mid 1950s with Ilsley Zecher's Thunderbird parked in front

Ilsley Zecher

Center by his interest in the art. He was elected treasurer of the SVA in 1959, a post he held until he became president in 1970. During his presidency the use of the Pavilion for community affairs was encouraged as were all of the activities for children and youth. Dr. Zecher felt that increased membership was vital to the continued viability of the Art Center and, during his tenure, the number of members doubled.

Margaret Sherwood Pierce came to the SVA office in 1973 and succeeded Hope Seamans in 1977. With a flair for the written word and a knowledge of funding sources, she prepared grant proposals to foundations and government agencies with a high degree of success. She designed and created the first Festival of the Arts catalogue and sold the advertising to make it possible. It was she who organized the archives and kept together the scattered bits of history about the SVA and the Art Center, and she who compiled the 50th anniversary booklet. She retired in 1989 leaving a legacy of loyal devotion not soon to be matched.

Mrs. Harold Boswell ("Petie") was a member of the Manchester Garden Club. In 1960, the Garden Club was asked for its help in improving the gardens and exterior of the house and grounds. Its members were already providing glorious fresh flower arrangements for the galleries and halls, adding a gracious welcome to the

ambience of the impressive house. In May 1964 Petie began the project which was to be her primary interest for the rest of her life. An ardent conservationist, it had long been her dream to clear a path through the forested area behind the house, to identify plant life, and to maintain a special botany trail as an adjunct to the art, music, drama, and dance of the Art Center. An easy half-hour walk, the trail includes a waterfall and pool, trees, ferns, and wildflowers, each with a permanent identification marker. A 300-year-old sugar maple tree in the Sculpture Garden is at the head of the Trail. In 1983, the Garden Club and the SVA Board of Trustees elected to name the walk The Boswell Botany Trail. The Manchester Garden Club continues to maintain the trail, the legacy left by Petie Boswell, who died in 1994.

Mrs. "Petie" Boswell reads to her granddaughters at the head of the Botany Trail

Betty Wilson, Louise Arkell's daughter, came to Manchester as the wife of portraitist Orland Campbell. She worked for years with her mother and husband in supporting the activities of the SVA and the Art Center. It was she who proposed dancing, both square dancing and ballroom dancing, at the Music Shed and encouraged wide participation by the community in activities on the hill. A talented fundraiser in her own right and a woman of creativity and limitless energy, she made her own mark on the SVA. Her marriage in 1974 to Stephen Wilson brought to the SVA a man of great charm and tremendous loyalty to the arts. The Board continues to rely upon the vision and wisdom that Betty Wilson brought to its ambitious capital campaign.

As part of the Art Center's contribution to the community, it would employ college-bound students for the summer months. High-school students Christopher Madkour and Melissa Guyette (Klick) were selected by Dr. Zecher in 1977. Melissa assisted in the offices and Christopher worked on the grounds.

Christopher was first asked to return to Vermont to serve as gallery assistant to the director, then Tom Dibble, while he was attending graduate school at the Amer-

*Betty Wilson and her
mother, Louise Arkell*

ican University in Cairo. He preferred to remain in Egypt. Later he
returned to Manchester and accepted the job as assistant to Executive
Director Tony Holberton-Wood. Though a seasonal position (the Art
Center was closed in the winter), Madkour's responsibilities quickly
grew to include not only assembling and hanging exhibits, but spe-
cial programming.

Christopher Madkour

In 1989 Christopher was appointed Executive Director, at
twenty-eight the youngest museum director in Vermont. It was not
until the day after his acceptance that he was told of the $35,000
deficit. Up to this time the SVAC had shied away from managing the
Center as a business. As federal and corporate funding dwindled dur-
ing the late 1980s–early 1990s, new and creative means of raising revenue were
sought. Christopher soon gathered support of Art Center members with corporate
experience to assist in the financial health of the organization. The Board appointed
Walter Freed, and later Robert Wentworth, as treasurer, who brought a sound, prag-
matic, and focused business acumen.

The young man who tended the grounds had fulfilled his dream of one day
being steward of the big white mansion and its rooms full of art.

The first Fine Arts Auction held in the Arkell Pavilion, August 1997

The Crest of the Wave

DURING THE LAST QUARTER of the 20th century, a wave of interest in cultural matters swept the United States. There was a boom in museum construction and fundraising, and innovative programming drew attention and audiences to existing museums. Stimulating the interest of youngsters became a goal for many art museums, and public school funding for art, drama, and music has been generous in some localities.

So great has the interest in art become that the Metropolitan Museum of Art was the number one tourist attraction in New York City in 1996. Traveling exhibits have taken Grandma Moses' work and biography to Chicago, Michigan, and Texas; Marc Chagall's work traveled to Boston and to the Clark Museum in Williamstown, Massachusetts. The Southern Vermont Art Center has been a part of this burgeoning interest in the arts and has also had the good fortune to have had boards of trustees willing to take risks. New ideas have been encouraged and new ventures have been given an honest chance to succeed.

The decision to remain "on the hill" during the winter months was pivotal to the successes of the nineties. Marjorie Lutz, SVAC's first woman president, and Christopher Madkour persuaded the Board of the need to become a year-round entity in order to increase membership, annual giving, and special programs. Undertaken with the aid of some special donations that helped winterize Yester House, and with the enthusiastic cooperation of the staff, this bold step has proved to be a wise one. Building on the success of the first couple of winters, November to April programs have been expanded and the response by the public has been heartening.

The holiday season lends itself to special events and exhibitions and to a series of classes that range from the creation of gingerbread houses to the decoration of Yester House itself. Decorated miniature trees and wreaths, donated by businesses and individuals, are in evidence throughout the galleries and are for sale. A gala preview party with ticketed admission and donated food begins this period, and in the galleries are hung special exhibits, including the "mini exhibition." This special challenge to artists requires that no painting be larger than 10 by 12 inches and that no work sell for more than $250. Popular with both artists and buyers, it has become a permanent part of the December offerings. Money raised during this period has been targeted for the restoration and maintenance of the Yester House gardens.

Christmas at Yester House

The winter shows, including solo exhibitions, maintain the high standards of the SVAC while allowing for more diversity and often including some of the less well-known artists in the area. A winter solstice show and a winter members' exhibition make for a busy post-holiday period and the 1997-1998 season featured a gallery set aside for student art. Beginning in 1992, artists from all over New England have been invited to submit work for the Annual Winter Exhibition.

An additional part of the winter schedule includes concert presentations by a variety of performers in the less formal setting of the galleries. Ron Levy and his Kaleidoscope group, singers Don Boothman, Pamela Hoiles, and Dee Tigue have entertained in concerts as have Jane Wood and other instrumentalists.

Children's' classes, held on Saturdays and limited in size, brighten the winter with innovative and creative ideas. Classes are held in drawing, building ice castles, making Valentines (and learning their history), making kaleidoscopes, dolls, whistles, kites, and learning about the 2,000-year-old tradition of decorating eggs. Highly

popular and featuring qualified instructors, these classes are a high point in the winter season.

By spring, it is time for the big "Art in the Schools Exhibition." This allows school children to see their work matted, framed, and professionally presented to the public. The enthusiastic participation of all the area schools and the positive responses from the public and from area artists

Christopher Makos, left, "Baby" Jane Holzer, former Warhol model, and artist Peter Wise were panelists at the symposium for the Warhol exhibition, August 1998

have made this a worthwhile, growing program. The three scholarships given by SVAC to students entering college in art programs is further indication of the Board's dedication to the fulfillment of the mission.

A turning point in the annals of the Art Center was the 1991 Warhol Exhibit. This was the first curated, museum-quality exhibition of Warhol's work in Vermont. It presented the historical side of contemporary art, integrated Warhol's life in text and photographs as well as in his work, and analyzed his artistic output. An unqualified success, this event set the stage for other large exhibits involving borrowed works from major museums and formed a foundation on which to build a capital fundraising campaign for expanded and improved museum space. In the autumn of 1998, First Vermont Bank sponsored a reappearance of that exhibition at SVAC.

An exhibit of the photography of Barry Goldwater in Gallery I was held in June of 1998, sponsored by State Representative Walter Freed. The photographs of the Grand Canyon and its people were from Senator Goldwater's private collection and from the Arizona Historical Foundation which he helped found. Senator Barry Goldwater died while the exhibition was being held here.

Barry Goldwater, c.1955

In 1985, Arlene Saltzman organized the first Artists Studio Tour which gave interested ticket holders the opportunity to visit the studios of regional artists, to view their work spaces, and to study works-in-progress firsthand. Woodworkers,

SVAC members and friends touring India, 1998

sculptors, potters, and painters throw open the doors of their barns, garages, special buildings, and simple rooms to the public on this day. This popular event takes place in July or August, is self-guided, and tickets are eagerly purchased.

In 1989 Christopher Madkour developed the SVA Travel Program with the inaugural trip to Egypt in November. Since then, twice-yearly trips, arranged through the Art Center, have become one of its most popular offerings. Participants must be members of the SVA and at least twenty-one years old—numbers are limited to twenty-five. Trips to Egypt, China, South Africa, Turkey, Morocco, India, and a safari in Kenya have been highlights of their respective years. Preparations include a series of seminars, open free to the public, on the music, art, and religion of the country to be visited. International tours in 1998 and 1999 included expeditions to South Africa and Alaska.

The Community Outreach Program, which began modestly when artist members of the SVA went into local schools to talk about art, has become a cornerstone of the effort to fulfill the mission of the Southern Vermont Artists. In 1995, the program sought to provide an educational experience for artists, art students, and young people. Working with area schools, the aim is to integrate the resources of the Art

Center with the schools' art programs through slide shows, talks, visits from artists, and trips. Every year a school group is taken to New York City to see a Broadway show and visit other Manhattan sites. For many children, this is their first trip to the Big Apple.

The Vermont Country Store has provided valuable support to the outreach-to-the-schools program. In 1997, VCS issued a challenge grant of $15,000 to other businesses to match its donation. Persuaded by the commitment of the SVAC to reach out to the larger community and to all constituents, and to share art in all its forms, the Country Store's support has proved to be an example to other businesses. As a result, scholarships for artists-in-residence, musicians, and dramatists were made available.

The Fall Art Show is one of the most prestigious in Vermont. Begun in 1956, it is, as always, a juried show and artists from throughout the country are invited to submit work. Exhibitors are eligible for the C. F. Orvis Sporting Award. This $1,000 award goes to the sporting scene of fishing, bird hunting, or to depictions of species of upland game or fish. The annual Grumbacher Award is given to the work best exemplifying outstanding technical quality.

The summer of 1997 featured two premier events which proved to be worth repeating. Director Madkour, had an inspiration while visiting summer resident Elizabeth Hoopes Krusen. Mrs. Krusen's career had been spent painting portraits of rooms—watercolors that pictured in intimate detail the rooms of some of the outstanding interior decoration in the country. Painting from

Burr and Burton students on the steps of the Metropolitan Museum of Art as part of the SVAC Outreach Program, 1999

the 1920s for some forty years, Mrs. Krusen's work is in a class by itself. Building from this germ of an idea, a symposium called "Arts for Living: Great American Designers" was organized. Her watercolors were exhibited as well as some of her landscapes. As

Distinguished speakers who participated in the 1998 Antiques in America symposium included, from left, John Bivens, Gerald Ward, Wendell Garrett, Betty Monkman, and Bill Sargent

Carolyn Colin addressing the Arts for Living symposium

guest of honor and the inspiration of the symposium, the eighty-nine-year-old lady was the woman of the hour. Preceded by a gala preview party, the symposium (under the outstanding chairmanship of Carolyn Colin and her committee) lasted for three days and brought together for the first time some of the most prestigious people in the world of design. John Loring, Senior Vice President and Design Director at Tiffany & Co.; Paige Rense, editor-in-chief of *Architectural Digest;* William Draper, society portrait painter; Langdon Clay, architectural photographer; Dan Kiley, world-renowned landscape architect; Catherine McCallum, senior designer at MacMillen, Inc., New York City; and Mario Buatta, the "Prince of Chintz," all were featured speakers. For them Vermont was a new adventure.

The Fine Art Auction came about as a result of overstuffed attics. Why not plan an auction for possessions too good for yard sales and not quite city-auction quality, thought Trustee Phyllis Lee, and make some money for the Art Center at the same time? As news of the auction spread, held during daytime hours in the hopes of attracting serious collectors and dealers, people began to phone offering a great variety of art and objects. Lyn Zweck-Bronner, co-chair with Phyllis Lee, was contacted by a friend who had lived many years in the southwestern U.S. and had a large collection of Indian artifacts. Pottery and baskets from that collection provided some of the most exciting lots in the auction. A beautiful George Luks watercolor was offered by a man whose mother had studied with the artist. The Fine Art Auction's festive preview party began a two-week display period with legions of volunteers organized by Dottie Ashton to guard the treasures. Phone inquiries and bids came in from all parts of the country, and the Fine Art Auction itself brought in $288,000 with a clear profit for the Southern Vermont Art Center of $60,000.

Building on that success, the 1998 Symposium "Antiques in America: Arts for Living" (again chaired by Carolyn Colin) featured five museum curators; topics ranged from Chinese export porcelain to Charleston furniture and the White House Collection. Completing the weekend, one of New York's largest auction houses, the William Doyle Galleries, organized by area resident and Doyle Galleries Regional Representative Leslie van Breen, marshaled eight experts to appraise the treasures of Art Center members—limit three items per member. Lectures on the auction process and the basis of appraisals informed the audience and proved highly entertaining.

Pete Childs, Jim Lee, and auctioneer Jim Dickerson at the second Fine Arts Auction. The sale of this Luigi Lucioni painting set a record price of $105,000, August 1999

The Film Festival, begun in 1970 by Wini and John Hawkes, is bigger and better than ever. Under the spirited leadership of Dawn Polis, the Film Festival now takes place in the Pavilion in a coffeehouse setting. Burr and Burton students set up chairs and small tables decorated with checked tablecloths and candles. A catered desert and coffee hour is included in the price of admission and is sponsored by Mulligan's Restaurant. Dubbed the "People's Choice Film Festival," six movies selected by the prior year's audience are shown.

A drama seminar, a wide variety of classes in drawing, painting, photography, sculpture, and carving are available for adults. Flower arranging, water gilding, and design have also been offered. Instruction is given by recognized artists, sculptors, designers, and certified instructors.

The concert series, a part of the Art Center's life since the first year, is a perennial crowd-pleaser. Its evolution has brought diversity to the stage of the Pavilion as jazz, symphony, ballet, and chamber music concerts liven the air. The Manchester Music Festival which began with pianist Eugene List and violinist Carroll Glenn has been under the leadership of world-famous cellist Michael Rudiakov since 1982.

ARTS FOR LIVING
Antiques in America

Sunday, August 16 APPRAISAL DAY 10 AM–2 PM
SOUTHERN VERMONT ART CENTER, MANCHESTER VT
Saturday, August 15 SYMPOSIUM 10 AM–4 PM

Peter Gould's mime workshop, 1998

A young visitor to the SVAC sculpture garden

Thursday evenings find the Festival Orchestra at the Art Center playing to capacity audiences.

The circle across from the front door to Yester House is each year the site of innovative, sometimes startling, always attention-getting works of art made of grass, metal, or other unusual material. These introductory pieces tend to bring a certain lighthearted whimsy to a visit to Vermont's premier cultural center. Further exposure for the outstanding examples of sculpture on hand at the Art Center is afforded by the Equinox Hotel where a small sculpture garden has been created.

Confident of its identity, the Art Center allows itself to laugh, to experiment, to challenge the imagination, and to have a good time without fear of damage to its reputation as a credible cultural institution. A series of children's films, a "Gould and Stearns" comedy show, a volunteer thank-you party, an artists' pot-luck supper, all cement the sense of family and community that mark the SVAC as a special place.

In looking for ways to attract new audiences to the Art Center, the idea arose of including astronomy in the fine arts. Other museums have integrated the astronomical sciences into their programs, and the discoveries of the Hubble Space Telescope have rekindled interest in heavenly bodies. Computers can be used to generate star maps, music inspired by the stars and the heavens is familiar to everyone, and much art uses the sky as background. By including local experts on a special com-

mittee, ways of combining astronomy and art and music have been found. Headed by Mary Lou Burditt, the committee included Eugene Kosche, former curator of the Bennington Museum, Dr. Errol Pomerance, author of "Sky Shows of Vermont," and Robert Bushnell actor/singer/teacher, who "had telescopes around," the project found form and substance. Working together this group organized a late September day in 1998 to "Celebrate the Stars." Free, as part of the Outreach Program, this day-long celebration included star art exhibits, a planetarium sky show, music, stories, a display of antique astronomical equipment, and an opportunity to view the stars through the Questar 7 telescope. A picnic supper on the grounds, planned to bridge daylight and darkness when star gazing could begin, made this family day a unique event.

Now with a membership of some 1,800, 700 of whom are artists, the Southern Vermont Artists, Inc. has evolved over the sixty-seven years since incorporation into a mature organization. In the fifty years of its existence, the Art Center has grown and surmounted

Michael Rudiakov and Manchester Music Festival musicians rehearsing in the Arkell Pavilion

obstacles to become a prestigious New England institution. Under the direction of a special events coordinator, volunteers and staff accomplish the tasks that are necessary to the myriad activities that make the air fairly vibrate with energy. The board of trustees is a healthy mix of new, high-profile, experienced people and longtime residents of the area who bring the perspective of history and knowledge of the community to the governing of the Art Center. A new advisory board will help the trustees with long-range and strategic planning.

Innovation and exciting programming, long the hallmark of the Art Center, continue to interest and amaze audiences and engage the committees year after year. Dependent on its volunteers as hard-working committee members, board members, hosts, docents, and active participants, the Art Center looks to the future with confidence and eager anticipation.

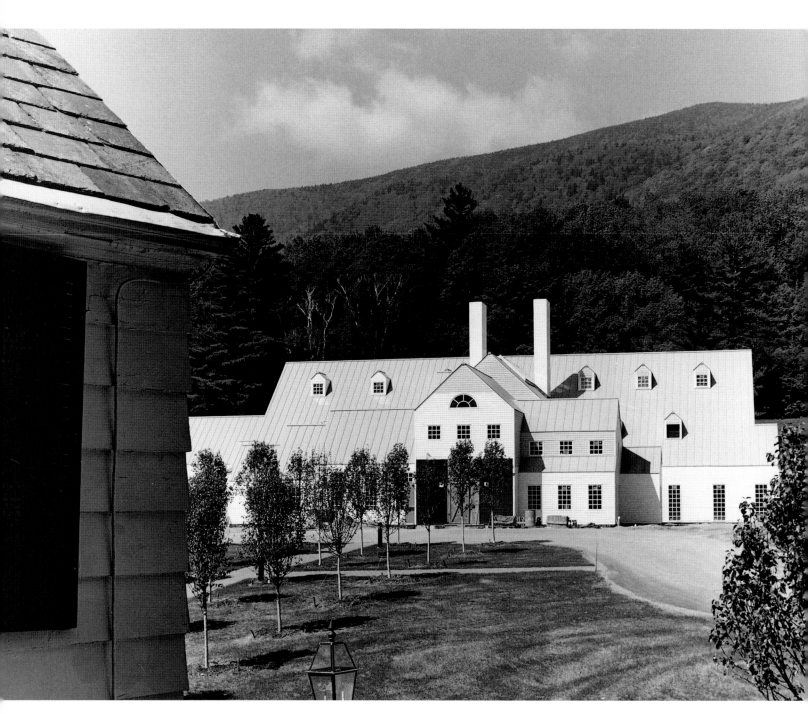

The Elizabeth de C. Wilson Museum nearing completion, June 2000

Fulfilling the Dream

T HE INABILITY OF THE Art Center to display its Permanent Collection has affected a number of programs over the years and, above all, has limited the numbers of gifts to this important component of the institution. Permanent Collections are the backbone of art museums and often the reputation of such an institution depends upon the quality of its permanent collection. The importance to the SVAC of owning works of its founders cannot be minimized and, fortunately, a good body of the work of these early members of the SVA rests in the Permanent Collection.

No acquisition funds are set aside to purchase paintings or other works of art for the Permanent Collection; all have been given by the artists themselves, by members, or by friends of the Art Center. Presently, more than 700 pieces, valued at more than $1 million, make up the Southern Vermont Art Center Permanent Collection.

Changes to the IRS laws in 1996 encouraged gifts of art (as well as other gifts) to museums and other institutions, and have had a salutary effect on acquisitions by SVAC for its Permanent Collection. During the early years various directors accepted the task of soliciting gifts for the collection with varying degrees of success. Many loyal supporters have donated important pieces of art to the Art Center as a statement of confidence in the institution.

Though items from the collection are on display in area banks, in the Manchester Town Hall, and at the Art Center itself, the bulk of the collection is stored as Yester House does not have adequate facilities for climate-controlled secure storage. Unfortunately, the old building can not be modified to provide it.

Executive Director Christopher Madkour, left, and architect Hugh Newell Jacobsen at the groundbreaking ceremony for the new museum and instructional center, July 11, 1999

A crossroads had been reached. It had become imperative that the trustees commit to a vision for their art center that would be in place for the millennium, a vision that would provide improved facilities for the protection and exhibition of the permanent collection. On a steamy day in June 1993, chairman of the long-range planning committee Louis Licht gathered his committee members Walter Freed, Jane Armstrong, Alex Hoffman, Marshall Peck, Chip Ams, Stuart Garrett, Tom Inslee, Jack Burditt, and Christopher Madkour to review the vision for the Southern Vermont Art Center. To be considered were short- and long-term objectives, including the enhancement of the permanent collection, improved facilities, programs and facilities to attract and exhibit the works of prominent artists, art education, research and publication, accredited art courses, expansion of volunteer workers, local art programs, better publicity, more focus on the endowments program, expansion of the scholarship and prints programs, and improved safeguards. All were thoroughly discussed, refined, and presented at the Executive Committee Meeting on August 17, 1993.

During Chip Ams' presidency (1995-97), Alex Hoffman assumed chairmanship of the long-range planning committee, and with the backing of the officers, a steering committee was formed to secure an architect, pursue fundraising options, and gain the support of the full board of trustees. Alex assembled a small core of trustees to serve with him on the steering committee which included Chip Ams, Jane and Jack Burditt, Randall Perkins, Pamela Kerr, Louis Licht, and the late Charles O'Connor. In 1996, honorary trustee Elizabeth Wilson responded warmly and generously to her old friend Christopher Madkour's request with the lead gift of $1.6 million. The Capital Campaign—"Fulfilling the Vision"—had begun. The timing for such fundraising was good, coming as it did during a national boom in the popularity of museums—art museums in particular—and with the stock market performing extremely well.

Guy Henry succeeded Chip Ams as president to oversee the actual construction of the facility and the completion of the Capital Campaign. Alex Hoffman,

Campaign Chairman Alex Hoffman seated with Joan Madeira at the groundbreaking ceremony

chairman of the Capital Campaign, worked tirelessly and end-lessly for the creation of the new facility. His leadership chair was Roby Harrington III, chair of the major gifts was Jim Lee, and Sue Robinson was chair of special gifts. Executive Director Christopher Madkour continued to coordinate the work of all the various sub-committees.

Bob Buck, Director of the Marlborough Gallery, NY, with Irene Hunter at the opening of the Larry Rivers Exhibition, 1998

The second-largest gift of $1 million for the campaign came in Spring 2000 from Gerald and Barbara Riley Levin in memory of their son Jonathan Levin. The Jonathan Levin Educational Endowment was established to expand the Center's Outreach Program. Now, children and young adults will have greater access and exposure to all the arts.

Important patrons included Joan and Louis Madeira who helped raise funds for the new Art Instructional Center, thus strengthening a year-round program. Generous monies were also donated by Mary Elizabeth and Ivan Combe to upgrade the Arkell Pavilion.

Long-time Art Center benefactors, Irene and Bing Hunter, have contributed generously for many years. As a trustee of the Paul Taylor Dance Company and patron of the New York City Ballet, Irene's passion for art and dance makes her a vital presence in the art world.

Because of Charles O'Connor's friendship with Hugh Newell Jacobsen, the

Jerry and Barbara Levin

Artist Kenneth Noland, whose paintings will be on exhibition in 2001, with his wife, Paige Rense, editor-in-chief, Architectural Digest

renowned architect was asked to look at the project and he quickly became an enthusiastic participant. He was attracted to the site and so intrigued with the idea of integrating a new building with the existing structures that he proclaimed to the board he'd "kill to design a museum on this wonderful site."

Hugh Newell Jacobsen has received over a hundred awards for design and is known for his precision, clarity, and formality. He was the architect for the West Terrace addition to the United States Capitol, the architect for the library at the American University in Cairo (the project where he met Charles O'Connor, employed at the time by the University), and for the restoration of the Smithsonian, among other projects. The challenge of creating a design in harmony with the classic architecture of Yester House and the Arkell Pavilion, adding contemporary details, and working with the sloping hills opposite Yester House, sparked his interest and presented him with a welcome challenge.

Working at the behest of the trustees, Jacobsen created a three-level building that appears to be all at ground level, sited on a piece of land that slopes toward Mt. Equinox. It contains 12,500 square feet and is intended to house two new galleries, curatorial storage space, a conference room, a gift shop, and offices. Security, fire, and climate control systems will allow SVAC to house and exhibit portions of its

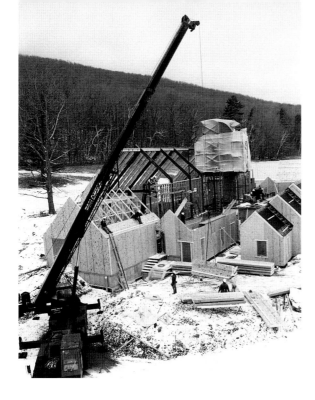

A crane lifts wooden wall panels into place during the early stages of construction, Winter 1999-2000

Trustee Roby Harrington III, right, congratulates architect Hugh Newell Jacobsen

Permanent Collection and will enable it to sponsor national and international exhibitions, borrow celebrated works of art, and take advantage of the traveling exhibits of other museums.

The Arkell Pavilion has been renovated, increasing seating and adding new lighting and acoustical systems. Modernized dressing rooms and backstage facilities now make it suitable for use by professional performers, and insulation and climate control will make it a three-season pavilion. Lobby space and exterior glass-enclosed walkways are designed to protect attendees from the weather. These improvements make possible the use of the Art Center as the permanent home of the Manchester Music Festival.

Along with fulfilling its vision of a first-rate art museum and credible performing art facility, the trustees and the staff have been ever-cognizant of the education component of its mission. A new docent program that offers historical perspectives and extensive knowledge of the artists will further enhance all programs and exhibitions.

Yester House remains the home of the exhibition galleries and the cornerstone of the Art Center. The Sculpture Gardens and the Boswell Botany Trail continue to play vital roles in the unique atmosphere of SVAC.

Two galleries will be part of the new museum: the Hunter Gallery will display travelling exhibitions and the Luigi Lucioni Gallery will exhibit rotating highlights of the Permanent Collection. The Gala Benefit and Opening Reception, to be held the weekend of July 22–23, 2000 will feature, as keynote speaker, J. Carter Brown, former Executive Director of the National Gallery in Washington, D.C. The opening exhibitions, curated by Christopher Madkour and Tom Fels, are "Napoleon in Egypt" and "Luigi Lucioni (1900–1988), A Centenary Retrospective of a Renaissance Realist."

DESCRIPTION DE L'EGYPTE, *an engraving from the opening exhibition, "Napoleon in Egypt," July 2000*

Gradually, what seemed only a dream became a plan and the plan became a real possibility. Financial support came from hitherto untapped sources, dreamers went to work, and reality overtook imagination—certainty overcame doubt. The vision for the millennium has become an achievable goal.

The next stage of development will be to establish an endowment for artist-in-residence programs where performers, writers, and painters can come for a summer and be inspired by the landscape of southern Vermont. As well, seeds have been sown to install a natural sculpture gallery along the beautiful drive leading up to the Center.

The Southern Vermont Art Center which has shown itself willing to take risks, encourage new ideas, and consider new ventures is once again looking to the future. The next fifty years promise to be innovative, exciting—and just beyond our farthest vision. The 1950 acquisition of the Yester House property was accomplished only with the help of many and with the goal always in mind. Fifty years later, the faces have changed, but the dream goes on.

And dreams do come true.

Selected Works from the Permanent Collection

From its early days, the Southern Vermont Arts Center
has collected the works of members, students, and friends
through donations. The acquisition of artwork is based on
the historic and aesthetic value of the piece to
the Collection.

I. JULIAN RIX, *California Landscape,* 1877
29 x 49 inches, oil, Gift of Elizabeth de C. Wilson

2. ALFRED STEVENS, *Solitude*, 1892
32 x 25 inches, oil, Gift of Martin Birabaum

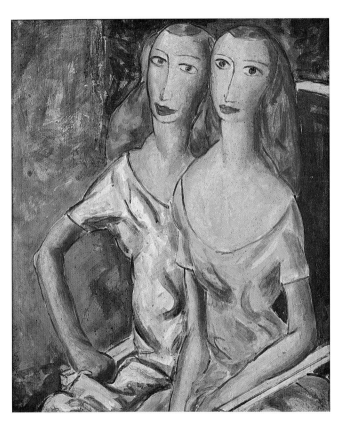

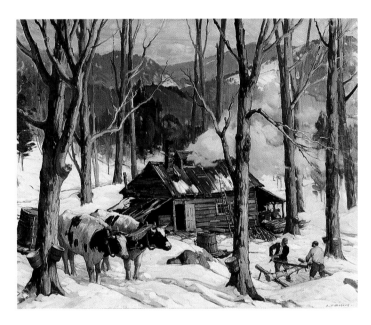

4. ALDRO HIBBARD, *Sugar House*
36 x 48 inches, oil on canvas, undated
Gift of Mrs. Mesa Briner

3. ALFRED MAURER, *Sisters,* c.1928
21 x 17 inches, oil
Gift of Mrs. Simon Moselsio

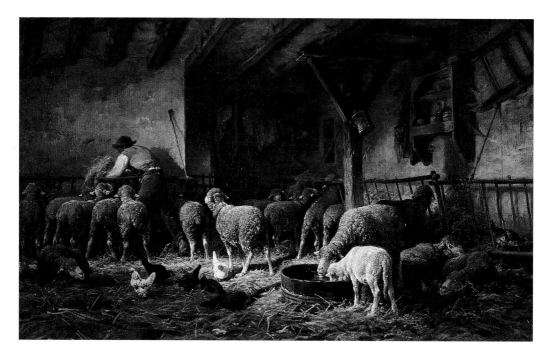

5. CHARLES-EMIL JACQUES, *Morning Feeding,* 1874
20 x 33 inches, oil, Gift of Mr. and Mrs. Willcox B. Adsit

6. JAMES MCNEILL WHISTLER
Fulham Bridge in Construction, c.1860
7 x 9 inches, etching, Gift of Pearl Higbie

7. JAY H. CONNAWAY, *Kelly's Farm, Dorset Hollow,* c.1950
20 x 24 inches, oil, Gift of Mrs. Jay H. Connaway

8. JARVIS MCENTEE, *Pool in Kingston Creek,* c.1870
10 x 13 inches, oil
Gift of Mrs. Reuben Crispell

10. JOHN KOCH, *Chrysanthemums*
30½ x 36 inches, oil on canvas, undated
Gift of the Artist

9. HENRY SCHNAKENBERG
Great Mosque, Cordoba
29 x 24 inches, oil, undated
Gift of Betty Bartlett Madden

11. JOHN STEUART CURRY, *The Cloud, Vermont,* 1930
28 x 34 inches, oil on canvas
Gift of Mr. and Mrs. Carl W. Painter

12. GORDON SAMSTAG, *Haircut*
21 x 21 inches, oil on masonite, undated
Gift of Bernice Webster

13. ROBERT BRUCE CRANE
Landscape, c.1900, 9 x 12 inches, oil on canvas
Gift of Mr. and Mrs. Stephen A. Wilson

14. JOHN ATHERTON, *Portrait of Carl Ruggles,* 1952
26 x 33 inches, oil on canvas, Gift of the Artist

15. FREDERICK JUDD WAUGH, *Off Monhegan*
28 x 36 inches, oil on canvas, undated, Gift of Mrs. Gerard Lambert

16. DAVID HUMPHREYS, *Pawlet Farm, Vermont,* c.1958
25 x 30 inches, oil on canvas, Gift of the Artist

17. REGINALD MARSH, *On the Bowery*, 1946
27 x 40 inches, watercolor
Gift of Mrs. Edward Browne

18. WALLACE FAHNESTOCK
Edwin LeFevre's Garden, Dorset, Vermont
25 x 30 inches, oil on canvas, undated
Gift of Mrs. Carroll Malone

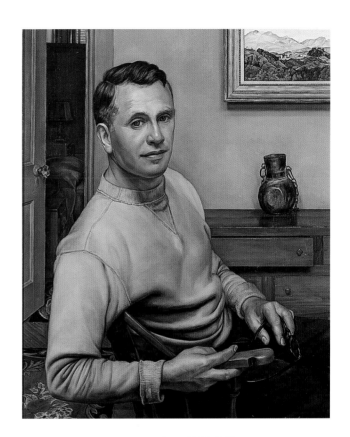

19. LUIGI LUCIONI
Self Portrait, 1949
32 x 26 inches, oil on linen
Gift of Mr. and Mrs. D. Mariboe

20. RICHARD ERDMAN
Formula IV, 1978
Italian Carrara marble
Gift of Martha Gogel and Patricia Page

21. AVEL DE KNIGHT, *Dawn*
40 x 30 inches, watercolor/gouache, undated
Gift of the American Academy of Arts and Letters

22. REGINA DELUISE, *Tree in Cardosa,* 1996
7½ x 9¼ inches, palladium print
Gift of the Artist

23. OGDEN PLEISSNER, *Blue Door, Venice,* c.1960
28 x 18 inches, watercolor
Gift of Mr. James Hind

FORMER PRESIDENTS

Robert J. McIntyre 1934

L.H. Shearman 1935–36

Judge Edward Griffith 1937

L.H. Shearman 1938–40

Ernest H. West 1941–44

Robert Warner 1945

Stanley B. Ineson 1946–50

John S. McCormick Jr. 1951–53

E.R. Brumley 1954

Charles E. Childs 1955–56

J.K. Adams 1957–58

Dean Fausett 1959–60

Carleton Howe 1961–70

Ilsley S. Zecher 1971–81

Frank L. Hutchins 1982–84

Harry A. Howland 1985–87

William S. Taylor 1988–89

Marjorie B. Lutz 1990–92

Marshall Peck Jr. 1993

Nancy Sparkman 1994

Charles M. Ams III 1995–97

Guy Henry 1998–2000

PHOTOGRAPH CREDITS

Unless noted, all photographs are from the archives of the Southern Vermont Arts Center, and all works of art belong to its Permanent Collection.

Bennington Museum: page 69 (left)

Dorset Historical Society: cover, pages 12, 14, 15 (top right), 34 (right), 50, 67 (left), 76

Manchester Historical Society: pages 17 (top), 18, 25, 32 34 (left), 35

Manchester Journal: page 29

Manchester Music Festival: pages 81 (bottom), 84

Merck Forest Foundation: page 95

Orland Campbell, Jr.: pages 36, 65, 90, 101 (left)

Photographs by Hubert Schriebl: pages 62, 94 (bottom), 96 (right), 112

Mr. and Mrs. M. Powers: page 106

Russell Vermontiana Collection: page 55

Supplied by the artist or by his/her family: pages 67, 71, 74, 75

South Londonderry Historical Society: page 59 (right)

Terry Tyler: pages 15, 33, 52 (left)

University of Vermont: page 52 (right)

THE AUTHOR

MARY HARD BORT IS A SIXTH-GENERATION Vermonter, a graduate of Burr and Burton Academy and the University of Vermont, and the wife of late U.S. Army Colonel Edward Bort. They have three children and two grandchildren.

After Army life took the Borts to Germany, North Carolina, California, Alaska, and the Washington, D.C., area, they retired to Manchester in 1975. Mary joined the Manchester Historical Society, edited a pictorial history of Manchester for the 1976 Bicentennial, and developed and taught a course in Manchester history at Ethan Allen Community College. She worked as a substitute teacher at Burr and Burton Seminary, then as a library assistant at Mark Skinner Library for thirteen years.

A charter member of the Friends of Hildene, Mary served on its Board of Advisors for fourteen years and then as a local history consultant for the Board. She was a member of the planning committee for the second Lincoln Symposium as well as a consultant and house docent for the third symposium.

Past President and now curator of the Manchester Historical Society, she served six years as a member of the Board of Trustees of the Vermont Historical Society, continues to serve on its Publications and Research Committee, and is a member of the Center for Research on Vermont. She has served as a member of the Board and past president of Manchester Health Services, the local home health agency, and is currently its vice president. She has served as both deacon and trustee of the First Congregational Church, was a member of its Bicentennial Committee, and edited a Bicentennial cookbook in 1984.

Since 1987, Mary has written a monthly column for *The Manchester Journal* on Manchester history and has conducted historical walking tours and bus tours of Manchester for the Historical Society and for visitors.